IMAGES
of America

GUILFORD

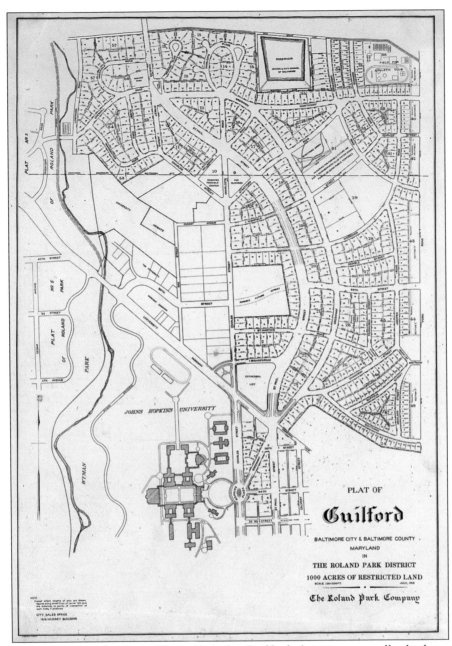

This is a 1913 plat of Guilford. When filed, the Guilford plat was reportedly the largest single Baltimore plat on record. Guilford was planned concurrently with the anticipated Episcopalian procathedral, Johns Hopkins University's Homewood campus, and Wyman Park. (Records of the Roland Park Company, MS 504, Box 292, Special Collections, Sheridan Libraries, Johns Hopkins University.)

ON THE COVER: Visitors fill Guilford's Sherwood Gardens on a sunny day in May 1955. This springtime display garden featured rare azaleas and thousands of tulips. Sherwood Gardens remains a springtime destination, attracting thousands of visitors annually. (Photograph by a *Baltimore Sun* staff photographer, courtesy of the *Baltimore Sun*.)

IMAGES
of America

GUILFORD

Ann G. Giroux

ARCADIA
PUBLISHING

Published by Arcadia Publishing
Charleston, South Carolina

Printed in the United States of America

Library of Congress Control Number: 2015930745

For all general information, please contact Arcadia Publishing:
Telephone 843-853-2070
Fax 843-853-0044
E-mail sales@arcadiapublishing.com
For customer service and orders:
Toll-Free 1-888-313-2665

Visit us on the Internet at www.arcadiapublishing.com

*This book is dedicated to the residents of
Guilford past, present, and future.*

CONTENTS

ACKNOWLEDGMENTS

Doors were opened, plans unfurled, and original architectural details proudly displayed. To those residents who answered an unexpected knock at the door and gave an impromptu tour, you made this book possible.

David H. Gleason, Paige Glotzer, Herbert Harwood, David R. Holden, Amy Kimball, Mary Klein, John W. McGrain, Douglas P. Munro, Walter Schamu, Scott C. Steward, Joseph Stewart, James F. Waesche, Dean R. Wagner, and James T. Wollon Jr. all assisted with this project. Valerie Addonizio, Benjamin Blake, Michael Johnson, Matt Shirko, and James Stimpert went above and beyond to provide images. Myra Collins, Beth and Stephanie Powers, Lauryn Nwankpa, Julia Shirley-Quirk, and Ann Margaret Zelenka assisted with research. The Abell, Dallam, and McDonald families and L. Gladstone, Kenneth R. Hubbard, and Fernando Pineda contributed photographs. Jeremy Hoffman located and organized historical images. Greg Pease, Brian P. Miller, Anne Gummerson, and Balance Photography provided contemporary photography. Naima Shoukat assisted with digital editing. Full Circle scanned hundreds of images. Clarinda Harriss and the estate of Margery and Robin Harriss granted permissions, as did Kristin Leopold. Keith Kellner prepared images for printing. Keri White assisted with copyediting. Ed Orser, Stephanie Powers, and Sandy Sparks reviewed the manuscript. Arcadia title manager Sharon McAllister brought everything together. My husband and two girls loved and supported me every step of the way.

Thanks go to the American Institute of Architects, Baltimore Architecture Foundation, Baltimore Museum of Industry, Baltimore Streetcar Museum, *Baltimore Sun*, Cathedral of the Incarnation, Enoch Pratt Free Library, Frederick Law Olmsted National Historic Site, Friends of Maryland's Olmsted Parks and Landscapes, Guilford Association, Johns Hopkins University Milton S. Eisenhower Library, Library of Congress, Maryland Historical Society, Maryland State Archives, George Peabody Library, Roland Park Country School, Second Presbyterian Church, Scottish Rite Temple, Smithsonian, University of Baltimore Langsdale Library, and University of Maryland, Baltimore County Albin O. Kuhn Library for their helpful contributions.

INTRODUCTION

The second collaboration of the Roland Park Company and the Olmsted Brothers Landscape Architects produced Guilford (1913), a luxury suburban development in North Baltimore endowed with lavish green space. Guilford coincided with an American mania for English architecture and town planning. Developers and architects traveled to England's suburban developments, especially those of Richard Barry Parker (1867–1947) and Raymond Unwin (1863–1940)—Letchworth (1903), billed as "the world's first garden city," and Hampstead Garden Suburb (1903). There, they embraced the organic landscape design, English town planning, and harmonious architectural treatment and adapted these strategies throughout the United States. Guilford transplanted the principles of those English developments to American soil.

In 1907, Baltimore real estate man Thomas W. Tongue assembled a group of investors to purchase Guilford, the estate of *Baltimore Sun* founder Arunah Shepherson Abell, for $1 million. They formed the Guilford Park Company and filed the deed to Guilford. Guilford was "said to be the biggest single tract of land sold for the biggest single price in the history of Baltimore's development" (*Baltimore Sun*, April 26, 1913). Spanning the center of Baltimore City at its northernmost boundary and spilling into Baltimore County, Guilford occupied a premier location. In 1907, Guilford provided nearly 300 acres of untouched farmland close to St. Paul Street, streetcar tracks, and developments to the south. Tongue called the endeavor a "gigantic undertaking" and promised, "There will be no solid rows of houses. Each residence will be detached and surrounded by lawns" (*Baltimore Sun*, March 8, 1907).

The Guilford Park Company hired the Olmsteds to develop the plan for Guilford. The projects of Frederick Law Olmsted Jr. and John Charles Olmsted broke with the gridiron treatments commonly employed at the time. The Olmsteds respected existing site topography, preserved natural scenery, employed heavily landscaped curvilinear streets, and incorporated distinct "places," as the Olmsted firm called them, such as cul-de-sacs. The Guilford enterprise stalled and eventually consolidated with the Roland Park Company in 1911. The Olmsteds were already working with the Roland Park Company, headed by Kansas City native and real estate developer Edward Henry Bouton (1859–1941), on nearby Roland Park, so work on Guilford continued.

Part of a shining new Baltimore, Guilford was to be what developers referred to as a "high-class" residential project developed concurrently with an Episcopalian procathedral, Johns Hopkins University's Homewood campus, Wyman Park, and the Baltimore Museum of Art. The well-parked campuses of these institutions would serve as a greenbelt along Guilford's western perimeter. Both Bouton and the Olmsteds were directly involved or advisories in each piece of the multipronged development. Newspapers marveled at the project's scope: "Brains, experience, genius and capital are combined in giving Baltimore a new suburban section that will combine beauty and individuality with distinction. The oldest inhabitant will not know his new Baltimore before long" (*Baltimore Sun*, August 10, 1912). Not everyone was pleased with the seismic shift to the suburbs. One city resident reacting to the relocation of institutions northward wrote, "There should be no need to

refer to the real unfairness to that large number in the old neighborhood who have continually been making sacrifices for the upkeep of the dearly beloved old place and who will not soon erect mansions at Guilford or Roland Park" (*Baltimore Sun*, November 9, 1914).

Guilford, however, was not designed as a development exclusively for the elite. Bouton marketed Guilford to families of modest means—an objective incorporated into the original Olmsted plan. The company sought "Bankers, Lawyers, Doctors, Architects, University Professors, Civil Engineers, Merchants, Manufacturers, Presidents of large corporations and other leaders in the professional and business world" (*Baltimore Sun*, December 11, 1913) but also advertised "Guilford, Destined to be Baltimore's Best Residential Section, an Ideal Place for Families of Moderate Means" (*Baltimore News*, October 3, 1913). Larger homes would be arranged predominately along main roadways and around parks. Smaller homes called "cottages" would be located along cross streets and around cul-de-sacs. Modestly priced attached homes would occupy the eastern and southern perimeters. This strategy accommodated more affordable homes yet maintained the effect of grandeur. Liberal inclusion of village greens, private parks, and larger community parks was part of the careful choreography for prospective buyers.

By the time the plans for Guilford were nearing completion, Bouton and his architect Edward L. Palmer Jr. had visited England, Germany, Belgium, and Holland. Upon his return, Bouton claimed "he had failed to find anything impressive in his visit," and said, "American architects are ahead of all the foreign architects so far as modern architecture is concerned." He grudgingly admitted that "in England we saw some things that were worth while" (*Baltimore Sun*, October 4, 1911). It is clear, however, that England made an impression.

Bouton was also working on Forest Hills Gardens (1911), a model community in Queens, New York, that combined Arts and Crafts aesthetics with the native City Beautiful movement and English town planning. Bouton may have been a counterweight to Grosvenor Atterbury, the Forest Hills Gardens architect who did not see eye-to-eye with the Olmsteds. Bouton's Guilford development drew heavily on his experiences at Forest Hills Gardens. Notably, the starting point for work at Guilford from architecture to sewage was based on a Forest Hills Gardens pamphlet on the same topic. Yet, it is sometimes difficult to decipher which development was leading and which was following.

Grosvenor Atterbury's aesthetic won out at Forest Hills Gardens, but the Olmsteds succeeded in Baltimore. Bouton was efficient and businesslike but also in sympathy with Olmsted design principles. Guilford received the full Olmsted treatment:

> Immediate steps will be taken by the company to have the roads, driveways and avenues "landscaped" in artistic curves that will enhance the rolling topography of the tract . . . To preserve its parklike appearance the streets and avenues will deviate from the usual system of new streets. This plan of development has been adopted in certain sections of Roland Park, but it will be more prominent at Guilford. (*Baltimore Sun*, January 16, 1909)

Atterbury was an advocate of attached housing, and early construction at Guilford included several attached housing projects. Atterbury designed none of these projects, although he served on Guilford's architectural advisory board. There is one Atterbury design preserved in the records of the Roland Park Company—a 1914 treatment of the southern entrance to Guilford with the kind of geometric landscape treatment Bouton disliked. Bouton did not use it.

It was Palmer who was responsible for Guilford's architectural aesthetic. He was Bouton's very own Parker and Unwin. Palmer designed many of the homes in Guilford, and he substantially revised plans submitted by others. Palmer's influence continued after he entered private practice. Palmer later formed a partnership with William D. Lamdin (1891–1945), a gifted architect with a particular talent for Old World charm. Today, Palmer is little known outside of Baltimore. But in 1947 when his peers nominated him for fellowship with the American Institute of Architects (AIA), Robert Edward Lee Taylor (1882–1952) of the firm of Taylor and Fisher wrote of Palmer:

Mr. Palmer's own work led in this crusade for better residential work . . . a standard was set which the rest of the world was proud and glad to follow . . . I will merely say that many years ago my partner, J. Harleston Parker of Boston said to me, on one of his visits to Baltimore, that he thought Palmer was doing the greatest service to residential architecture that was being done in America at the time. (The American Institute of Architecture Archives, March 25, 1947)

Laurence Hall Fowler (1876–1971) also contributed to the success of Guilford. Fowler had a more classical training than Palmer, but they were both incredibly refined architects, capable of considerable restraint. They employed novel solutions to elevate projects from the mundane to the sublime. Fowler served on the Roland Park Company Architectural Review Board from 1927 to 1935. Together, Palmer and Fowler ensured that Guilford homes were uniformly well designed.

Guilford was a premium development both for the quality of the design and construction of homes and also for the generous allocation of green space. Guilford was planned with three community parks—the Little Park, Sunken Park, and Stratford Green, now part of Sherwood Gardens. The company could not acquire the land for the intended fourth park, Residence Park. At Bouton's insistence, Guilford's plan also included several parked "places." Like Forest Hills Gardens, some blocks were also planned with private parks available only to adjoining residences. Architecture was important, but people were really buying green space.

They were also buying homes with guarantees; restrictions ensured life in a country setting without country nuisances. Categories of activity were prohibited, such as operating a forge and keeping livestock. Eventually, entire categories of people were also excluded from the company's developments—part of a nationwide trend. When Guilford opened in 1913, the company's booklet of "don'ts" prohibited African American home ownership outright. Additional categories of undesirable people—Jews, immigrants with "impossible" names, and members of specific pariah professions such as undertakers—were excluded with the help of so-called gentleman's agreements. The Roland Park Company did not pioneer these discriminatory practices, but its outsized influence encouraged their proliferation both locally and nationally. The Great Depression marked the beginning of a slow death of discriminatory sales practices in Guilford.

Restrictions concerning property use and maintenance did ultimately preserve Guilford. The fine country homes erected near, but not within, Guilford's boundaries serve as, according to author Eileen Higham, "a cautionary tale." On the western perimeter, grand homes along North Charles Street, including Ascot House, Belle Lawn, Everbright, and Phillipshurst, have been lost. The small Oak Place development is also largely gone. To the south, the Bauernschmidt residence was replaced with an apartment house. The Roland Park Company's 1915 advertisement warning "Building Restrictions Would Have Averted This Trouble" was certainly prescient.

Guilford promised a pastoral paradise free of the disease, crime, and haphazard planning of the city core. It was, however, the promise of the best modern architecture in a sylvan setting where the Roland Park Company truly succeeded. Guilford contains some of the nation's finest examples of suburban residential architecture. These homes delight today just as they did a century ago. Guilford, now a National Register Historic District, remains a showcase American garden suburb.

One

"WITH ITS MEADOWS, ITS GLADES, AND ITS OLD WOODLANDS"

In 1822, Revolutionary War veteran Lt. Col. William McDonald (1758–1845) purchased a large experimental farm from Ebenezer Smith Thomas (1775–1845), a newspaperman, printer, bookseller, and former member of the Maryland House of Delegates who had suffered financial losses. To this land, McDonald added in 1830 the small tract known as "Sheridan's Discovery." McDonald renamed his estate for the battle of Guilford Courthouse in North Carolina where he had fought and sustained injury.

When McDonald died, he left two sons, but the eldest son, Samuel, died just four years after his father. The estate in its entirety fell to Samuel's half brother William McDonald Jr., known as "Billy." Billy commissioned an Italianate villa from the architect Edmund George Lind (1829–1909), who was then associated with William Turnbull Murdoch (1827–1903). Construction on the approximately 50-room residence was completed around 1858. Some years later, Lind designed the Peabody Institute's west building (1861), but he is best known for the George Peabody Library (opened 1878) in the east wing—considered one of the most beautiful libraries in the world.

Ill-fated Billy died at the age of 35 from illness following imprisonment at Fort McHenry. Guilford was sold in 1872 to Arunah Shepherdson Abell (1806–1888), who had founded the *Baltimore Sun* with two partners. Abell acquired additional land adjacent to Guilford, including portions of Clover Hill Farm, but he also owned Woodbourne near Govans and Litterluna in Greenspring Valley. The Abells spent time at Guilford during the summer and also had a townhouse in the city. Abell died in 1888, and after numerous offers, his heirs sold the estate in 1907.

Guilford encompassed almost 300 acres of undeveloped land at the city's northern boundary, replete with pristine pasture, woodlands, and many fine specimen trees. In 1912, the impending transition from rural retreat to modern housing development was considered with some wistfulness: "Guilford . . . with is meadows, its glades and its old woodlands is soon to give up its individuality to the fast-spreading city" (*Baltimore Sun*, May 17, 1912).

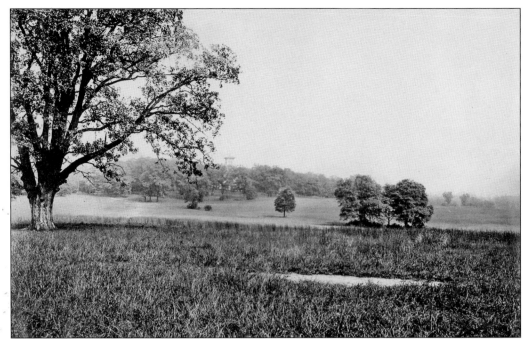

Much of the undeveloped Guilford estate looked as it appears in these photographs. Gently rolling fields dotted with stands of mature trees were crossed with an occasional narrow and unpaved lane. In the photograph above, the main house peaks out over the trees. In the photograph below, a man leans against the fence to the left and looks out over Guilford. (Both, records of the Roland Park Company, MS 504, Box 295, Special Collections, Sheridan Libraries, Johns Hopkins University.)

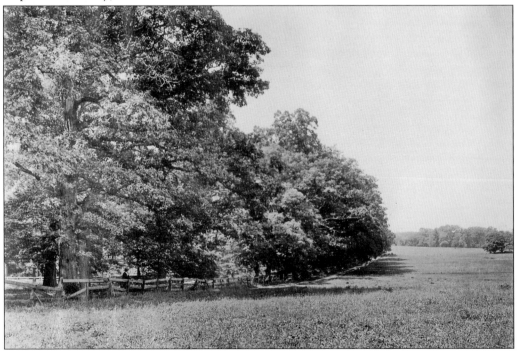

When Guilford was sold for development, an older home, possibly the original McDonald residence, still stood. This outdated residence, close to present-day Chancery Square, may have been quarters for Elisha Riddle, the farm manager at Guilford for 40 years (1872–1912). Prior to working at Guilford, Riddle had served in the same capacity at Abell's Woodbourne estate. An elderly widower, Riddle left Guilford to live with his son shortly after the Roland Park Company took over. The company refurbished the home and used it as the sales office for Guilford. The reprieve was short-lived, and this house was eventually torn down. In the photograph at right, the sign affixed to the front of the building reads "Sales Office." (Above, photograph by a *Baltimore Sun* staff photographer, courtesy of the *Baltimore Sun*; right, records of the Roland Park Company, MS 504, Box 292, Special Collections, Sheridan Libraries, Johns Hopkins University.)

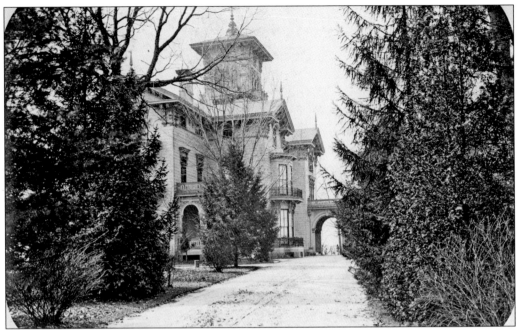

The Italianate style was popular during the 1850s, made fashionable by the nation's tastemaker, Andrew Jackson Downing. Downing's influential *The Architecture of Country Houses* (1850) includes Richard Upjohn's design for a villa in Newport, Rhode Island. The Wymans' nearby Homewood Villa (1853) drew heavily from the Upjohn design, and numerous smaller country houses bordering Guilford were constructed in this style. Above is the approach to the Italianate Guilford villa framed with trees. Below, the Abell family is gathered at Guilford. Arunah S. Abell is thought to be the gentleman standing just in front of the carriage. (Both, A.S. Abell family photograph album, private collection.)

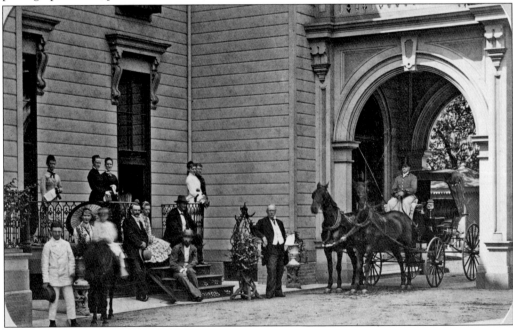

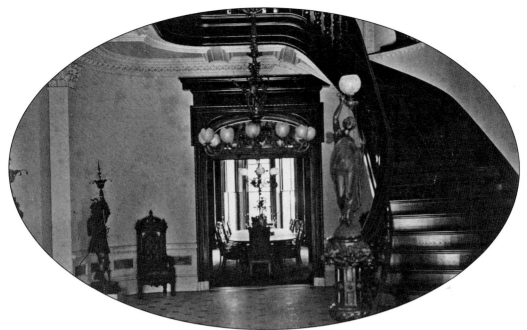

The Guilford villa had the latest amenities (both hot and cold water) as well as lavish appointments not seen in smaller houses. Specialized rooms included a smoking room and an armory. The marble-floored entry hall, shown above, had a curved stair with an ornate statue-topped walnut balustrade. The bottom photograph shows a typical view of a furniture-filled room complete with carved stone fireplace surround topped with the best bric-a-brac money could buy. The Roland Park Company demolished the villa in 1914, but first sold off the fireplace surrounds and other saleable items. (Both, A.S. Abell family photograph album, private collection.)

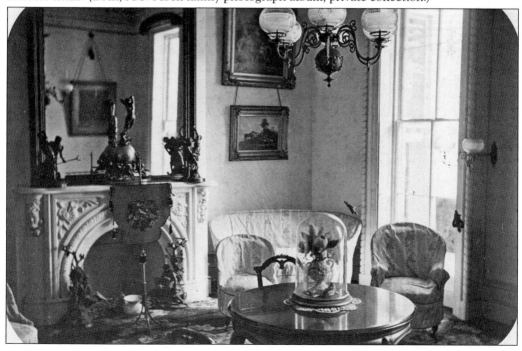

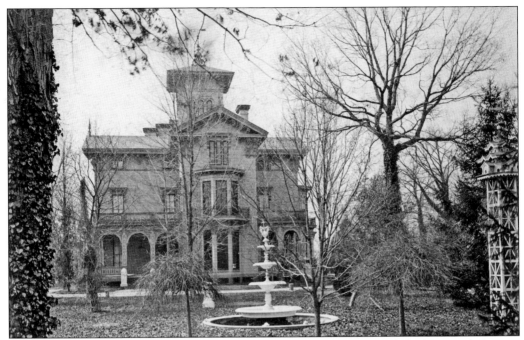

Guilford was mostly fields and meadows dotted with stands of trees and thickly wooded areas, but the estate around the villa was well landscaped, employing the picturesque treatment favored by Andrew Jackson Downing. As with the suburban development that would supplant it, the landscaping eschewed rigidly geometric planting schemes. The photograph above shows a view of the garden; on the right there is a little bird villa matching the main house in grandeur. Below, members of the Abell family are pictured enjoying the grounds and playing croquet. (Both, A.S. Abell family photograph album, private collection.)

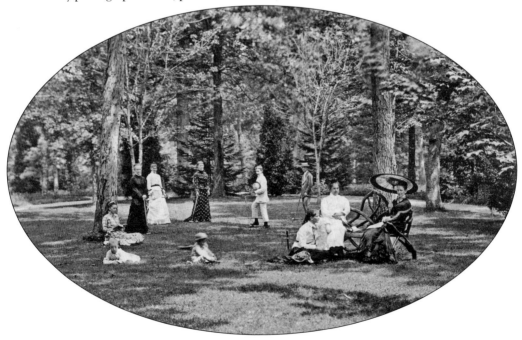

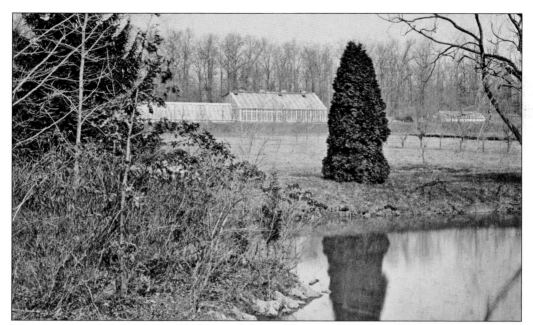

The grounds included a man-made boating lake with two small islands, a footbridge, and walking paths conducive to contemplative meandering. The family members slept under mosquito netting during the summer months, likely due to the proximity of the lake. Smaller structures, including the greenhouse (seen here in the distance) and a grapery, dotted the estate. (A.S. Abell family photograph album, private collection.)

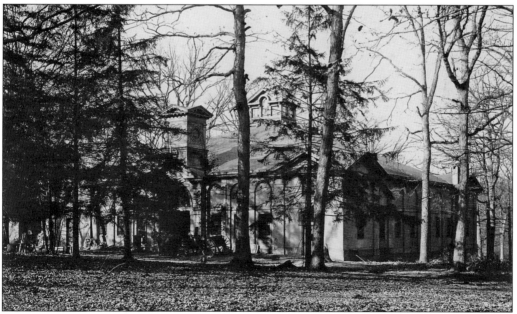

Billy McDonald's grand brick stable, also designed by Edmund G. Lind, housed the record-breaking mare Flora Temple, dubbed "Queen of the Turf" by the *New York Times* and memorialized as the "bob-tailed nag" in Stephen Foster's "Camptown Races." Today, glass whiskey flasks bearing her likeness are a collector's joy. (Records of the Roland Park Company, MS 504, Box 292, Special Collections, Sheridan Libraries, Johns Hopkins University.)

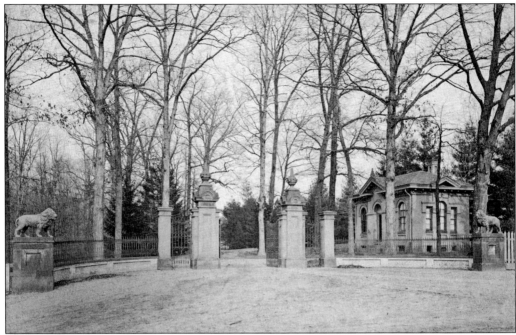

Guilford had formal entrances on York Road (above) and on a narrow unpaved lane that is now North Charles Street. These entrances had curved gates, lion statues, and gatehouses. The Charles Street entrance (below) forces travelers to make a sharp turn to the left. The sign placed next to the street lamp cautions vehicles to "Slow Down" to prevent people from crashing headlong into the gate. Present-day North Charles Street still follows the original Abell estate boundary. (Above, A.S. Abell family photograph album, private collection; below, records of the Roland Park Company, MS 504, Box 295, Special Collections, Sheridan Libraries, Johns Hopkins University.)

Guilford was not an isolated outpost. Waverly sat opposite Guilford across York Road (now Greenmount Avenue), a major north-south corridor. Waverly was a bustling village well before shovel hit earth in Guilford. The photograph above, taken from the Guilford villa, shows Guilford's fields in the foreground and Waverly off in the distance. To the west, featured below, Guilford's perimeter was dotted with smaller country houses such Belle Lawn. (Both, A.S. Abell family photograph album, private collection.)

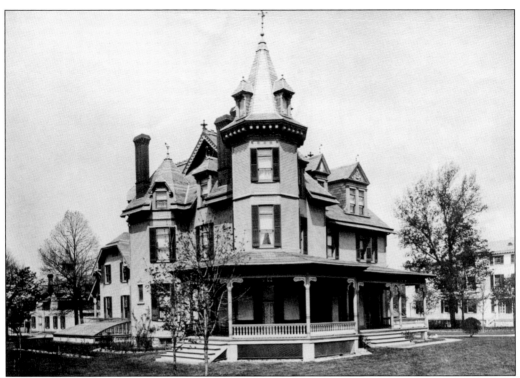

Guilford's neighbor, the Victorian Belle Lawn, belonged to businessman Maj. George Washington Hyde. Built around 1880, Belle Lawn had a generous 23 rooms, a turret, gables, and porches. When Belle Lawn was built, Gothic and Italianate styles were no longer fashionable. Shown here as it looked in 1908, Belle Lawn was demolished to make way for the Warrington Apartments in 1927. (Photograph by a *Baltimore Sun* staff photographer, courtesy of the *Baltimore Sun*.)

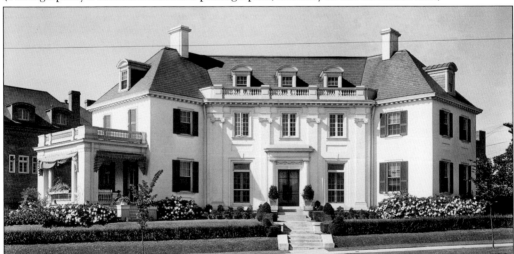

The architectural firm of Ellicott and Emmart (see page 69) designed this home for brewer William Bauernschmidt in 1907. Occupying a lot on the Cotter tract just to the south, this fashionable residence looked at home next to Guilford for many years. Eventually, this house too was demolished, replaced by the University One apartment building. (Hughes Company Glass Negative Collection, the Photography Collections, University of Maryland, Baltimore County.)

Two

"THE BIGNESS OF THE WORK"

The company assumed control of Guilford in 1911. Already at work on Roland Park, the Roland Park Company now had another large property that needed everything. The company was responsible for the infrastructure, including electrical service, water, and sewage. It had to lay sidewalks, surface roads, install sod, and plant trees by the thousands. Newspapers strove to convey the enormity of the undertaking to the north of the city:

> Another big feature of the development is the parking of Guilford . . . It is estimated that at least 150,000 trees and shrubs will be used in the sidewalk lawns and slopes. This number represents about 60 box carloads of horticultural products. The figures merely give an idea of the bigness of the work, which is one of the largest and most ambitious attempt[s] to create a residential "City Beautiful" in [A]merica. (*Baltimore Sun*, October 13, 1913.)

Many doubted publicly that a project of such scope could be realized. But, by spring of 1913, the company had elegant model homes ready for inspection. All agreed the Roland Park Company had proved the naysayers wrong.

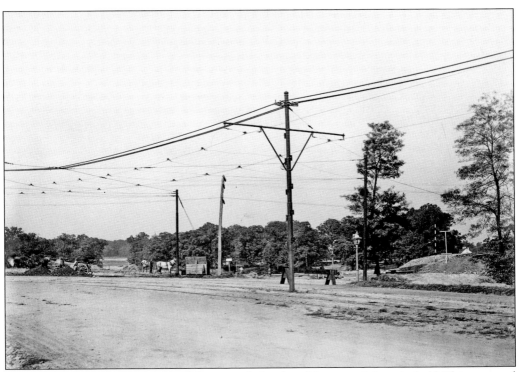

University Parkway, above, began life as a path dividing Merryman's Lott in half. This unpaved connection between York and Falls Roads was named Merryman's Lane in 1801. In *Baltimore: A Not Too Serious History*, Letitia Stockett recalls Merryman's Lane as "sweet with locust trees." Abell's lands included Clover Hill Farm, which was bordered by Merryman's Lane to the south. Both the residence known as Clover Hill (1720, 1869) and St. Paul Street, newly extended into Guilford, are pictured below. (Above, records of the Roland Park Company, MS 504, Box 286, Special Collections, Sheridan Libraries, Johns Hopkins University; below, records of the Roland Park Company, MS 504, Box 301, Special Collections, Sheridan Libraries, Johns Hopkins University.)

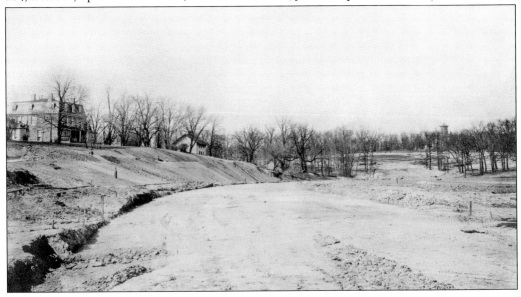

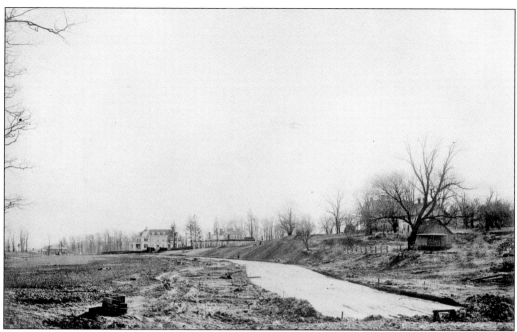

According to records, the Olmsteds were pleased to find "very nice oaks . . . well worth saving even at some expense and warping of grades," but many trees were cut down. To help those working at Guilford, small signs bearing the names of future streets were located throughout. In the photograph below, the top of the Guilford villa on the right and a small sign marking the intersection of Chancery Square and Chancery Road (here Chancery Street) are the only clues to the photograph's location. (Above, records of the Roland Park Company, MS 504, Box 301, Special Collections, Sheridan Libraries, Johns Hopkins University; below, records of the Roland Park Company, MS 504, Box 292, Special Collections, Sheridan Libraries, Johns Hopkins University.)

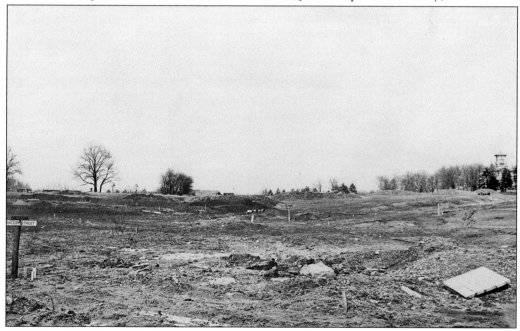

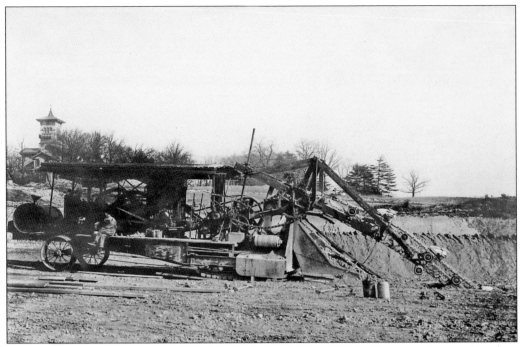

Trenching machines and steam shovels were the predecessors to the heavy equipment found on any jobsite today. Yet this modern equipment was used in conjunction with horse-drawn carts. Furthermore, much of the work at Guilford was actually done by hand with pick and shovel. (Both, records of the Roland Park Company, MS 504, Box 292, Special Collections, Sheridan Libraries, Johns Hopkins University.)

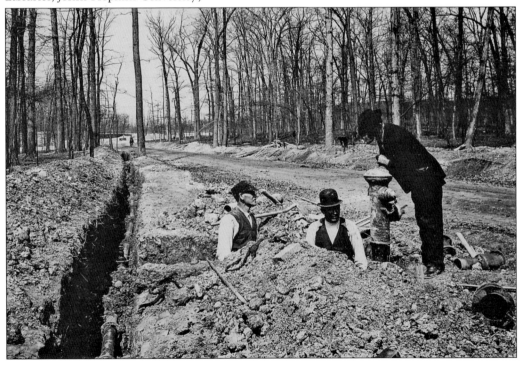

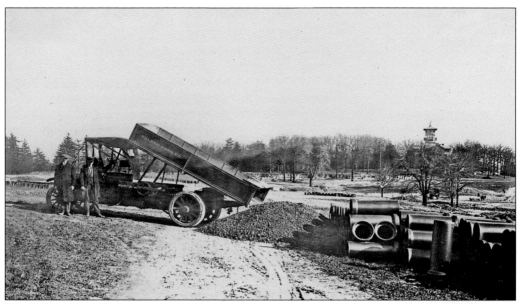

The Roland Park Company required large quantities of material. These materials included sewage pipes for infrastructure (above), lumber for the homebuilding phase (below), and vast amounts of plant material for landscaping. The scale of the construction was exceptional: "Four large automobile trucks haul sand for the operations continually, night and day, and near the tract the company has its own lumberyard, carpenter shop and supply storehouse, to which a spur of the Maryland and Pennsylvania Railroad runs direct" (*Baltimore American*, April 13, 1913). Indeed, weary St. Paul Street inhabitants to the south of Guilford eventually protested the nighttime runs of the company's gravel trucks. (Above, records of the Roland Park Company, MS 504, Box 292, Special Collections, Sheridan Libraries, Johns Hopkins University; below, records of the Roland Park Company, MS 504, Box 301, Special Collections, Sheridan Libraries, Johns Hopkins University.)

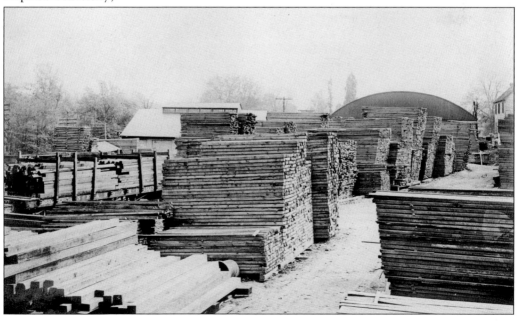

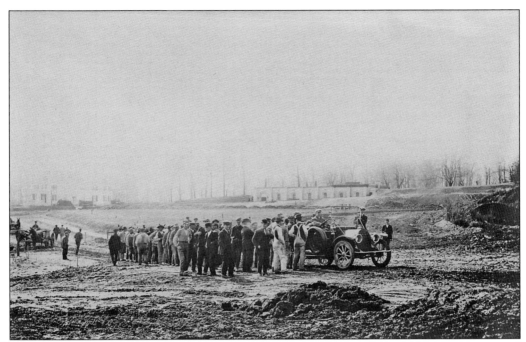

The Roland Park Company also needed large numbers of men. During the infrastructure and road-construction phase, the company employed many laborers. In the photograph above, the men gather in Guilford to receive their wages from the pay car in February 1913. In the background, one can just see the Bauernschmidt house to the left and the undercroft of the planned procathedral. In the photograph below, laborers dig a trench near Greenway and St. Martins Road. (Above, records of the Roland Park Company, MS 504, Box 292, Special Collections, Sheridan Libraries, Johns Hopkins University; below, Maryland Historical Society, MC5891-68.)

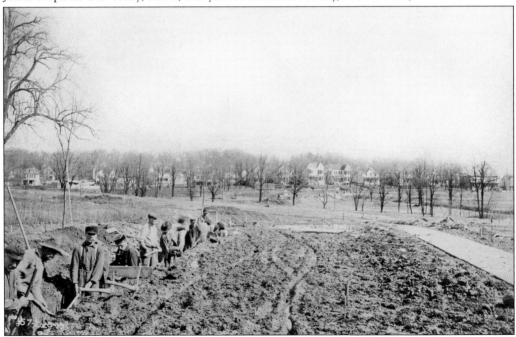

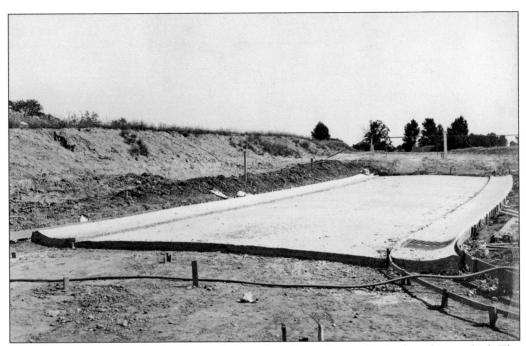

Sewage pipes were installed, and granolithic sidewalks and macadamized roads were laid. The photograph above shows the paving of Newland Road. The company was proud of the quality of its roadways, which employed concrete foundations and gently depressed gutters for durability and drivability. In the photograph below, men, with the aid of horse and cart, lay new sidewalk on the east side of Greenway between Wendover and Highfield Roads. (Above, records of the Roland Park Company, MS 504, Box 293, Special Collections, Sheridan Libraries, Johns Hopkins University; below, records of the Roland Park Company, MS 504, Box 292, Special Collections, Sheridan Libraries, Johns Hopkins University.)

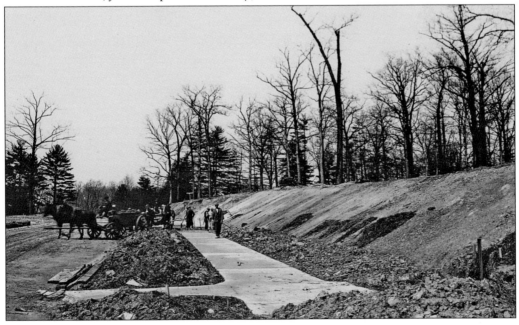

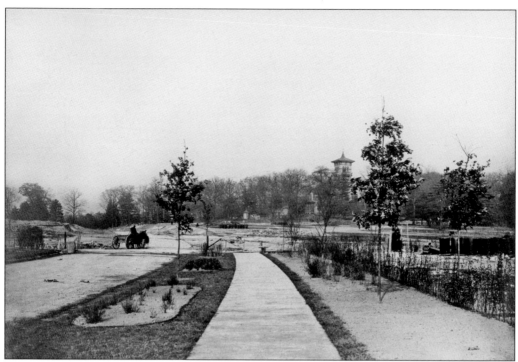

Thousands of trees, shrubs, and perennials were planted. Above is the Olmsted landscape design for Guilford being executed along Greenway just south of Thirty-ninth Street. Median strips were planted with both trees and shrubs. Pictured below is a newly planted triangle at Northway; the Olmsteds employed triangles to soften and calm intersections. (Above, Maryland Historical Society, MC5891-81; below, records of the Roland Park Company, MS 504, Box 286, Special Collections, Sheridan Libraries, Johns Hopkins University.)

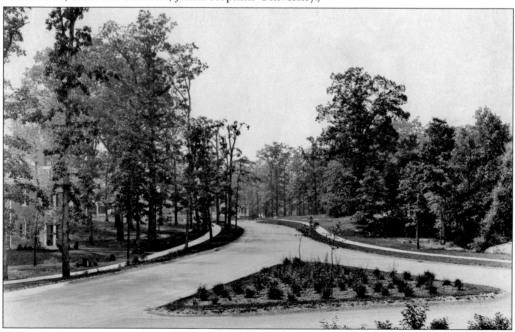

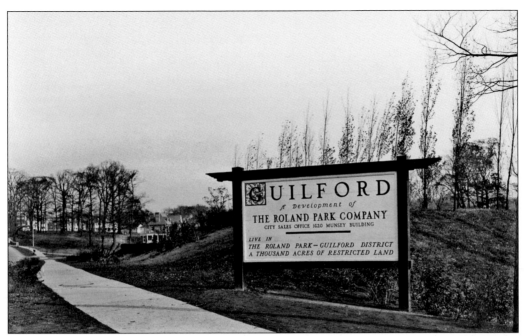

With many roadways and sidewalks laid and planted and model homes nearing completion, the company readied itself for prospective buyers. The company's sign declaring "A Thousand Acres of Restricted Land" echoes the promotional efforts of Forest Hills Gardens. Visitors to Guilford would proceed to a temporary building just south of the procathedral undercroft. Company employees would then ferry visitors to see the model homes and available lots. (Above, records of the Roland Park Company, MS 504, Box 295, Special Collections, Sheridan Libraries, Johns Hopkins University; below, records of the Roland Park Company, MS 504, Box 293, Special Collections, Sheridan Libraries, Johns Hopkins University.)

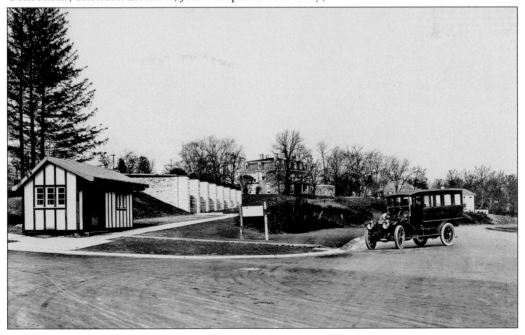

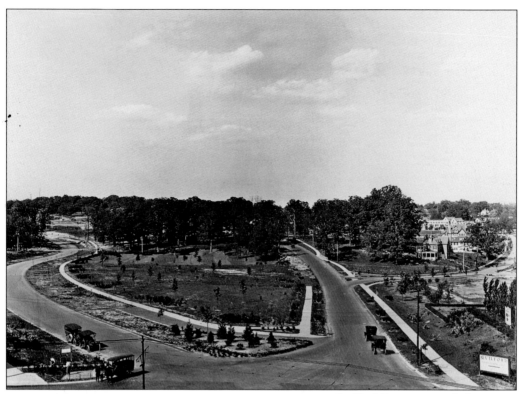

St. Paul Street, extended across University Parkway into Guilford, is graceful and undulating (above); on the right, Chancery Road and Chancery Square homes are completed, and homes bordering York Road are under construction. Not shown is Oakenshawe, the small estate just east, to be developed by Philip C. Mueller with "high-class" row houses. On the right sits the Guilford sign referenced earlier. Just north, another sign announces St. Ignatius Church (left), but this site would become apartments instead. (Above, records of the Roland Park Company, MS 504, Box 295, Special Collections, Sheridan Libraries, Johns Hopkins University; left, records of the Roland Park Company, MS 504, Box 293, Special Collections, Sheridan Libraries, Johns Hopkins University.)

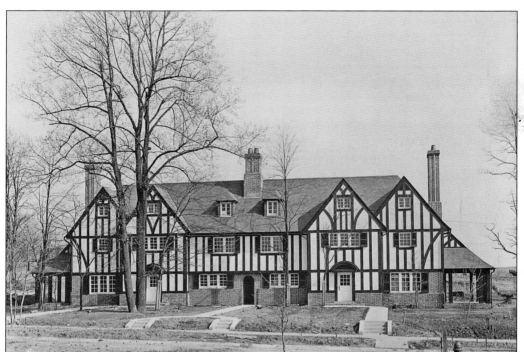

On May 19, 1913, the Roland Park Company opened Guilford to public inspection with excitement but "no brass bands" (*Baltimore Sun*, April 26, 1913). Edward L. Palmer Jr.'s Chancery Square served as the model homes. An Olmsted "place," Chancery Square consists of three large twin Tudor Revival homes set around a long rectangular green planted with trees. Set well back from the street, these elegant homes have facades of brick, stucco, and half-timbering, steeply pitched slate roofs, and prominent chimneys. The model homes were impressive enough to show Baltimore's elite what was possible and modest enough that less-affluent buyers saw potential in Guilford. (Both, records of the Roland Park Company, MS 504, Box 293, Special Collections, Sheridan Libraries, Johns Hopkins University.)

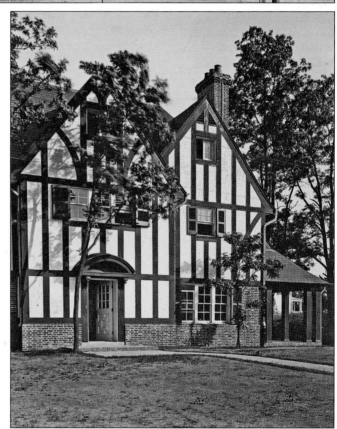

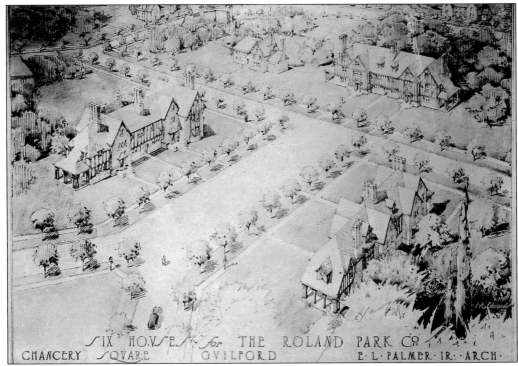

SIX HOUSES for THE ROLAND PARK CO
CHANCERY SQUARE GUILFORD E·L·PALMER·JR·ARCH·

Early illustrations of Chancery Square do not include the rectangular green in the center. The photograph below shows the initial planting arrangement. The newly planted toothpick-sized trees seem comically small. The planting plan included shrubs and perennials in the center green and along the sloping lawns of individual homes. One early Chancery Square resident was C. Howard Millikin, president of the Hennegen Bates Company, an important jewelry and silver concern. (Above, records of the Roland Park Company, MS 504, Box 292, Special Collections, Sheridan Libraries, Johns Hopkins University; below, records of the Roland Park Company, MS 504, Box 293, Special Collections, Sheridan Libraries, Johns Hopkins University.)

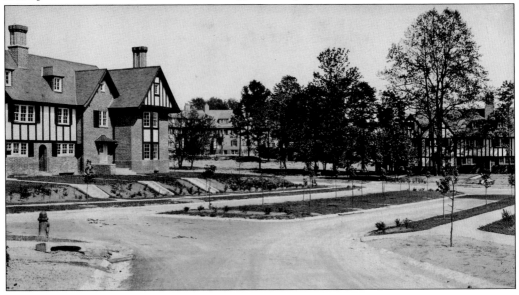

Three

"An Organic Whole"

In 1912, the Roland Park Company announced an architectural advisory board for Guilford consisting of landscape architect Frederick Law Olmsted Jr., New York architect Grosvenor Atterbury, and Baltimore architects James Bosley Noel Wyatt and Howard Sill, in addition to the company's own architect, Edward Livingston Palmer Jr. (1877–1952). This article marks a rare public mention of Palmer during his tenure with the company, but it was Palmer who designed hundreds of homes in the company's developments and reviewed and revised plans submitted by others for commissions in Roland Park and Guilford. Ultimately, Palmer was responsible for Guilford's architectural aesthetic.

Palmer enjoyed an enviably short path from draftsman to career prominence. He graduated from Johns Hopkins University in 1899, received a degree in architecture from the University of Pennsylvania in 1903, and worked briefly in the Washington, DC, office of Joseph Coerten Hornblower (1848–1908) and James Rush Marshall (1851–1927). Palmer then joined the Roland Park Company, where his work quickly garnered national attention. Palmer held this position from 1907 until he transitioned to private practice in 1917. From 1925 on, Palmer partnered with William Duncan Lamdin (1891–1945). Together they continued to design fine residential projects and also received ecclesiastical, university, and hospital commissions.

An artful master of balance and proportion, Palmer sought harmony in his projects. He said, "When atention [sic] was given to domestic architecture first . . . you would see a good doorway, or a porch perhaps, on a building that was otherwise ugly . . . there was no harmony . . . It was some time before architects understood that a building should be an organic whole" (*Baltimore News*, April 1, 1916). Of the Roland Park Company's district, Palmer said, "Show me anywhere in the world a piece of land, developed according to a plan . . . where there are as few mistakes; where the worst is as good as it is, and the best as excellent as it is" (*Baltimore Sun*, November 22, 1920).

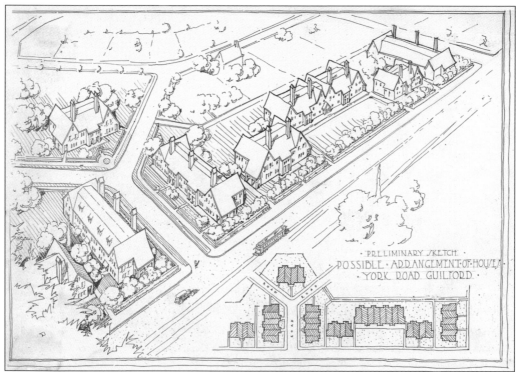

The company first developed Guilford's southeast quadrant, including Chancery Square and the attached homes of Bretton Place and York Courts (above). That first year, Bretton Place and York Courts were the "biggest building operation at Guilford" (*Baltimore Sun*, June 25, 1913). The photograph below documents newly constructed homes at Bretton Place from the intersection of Suffolk and Newland Roads. Palmer designed Bretton Place as "an organic whole"; each group is a well-balanced entity, not simply a series of identical homes strung together. (Above, records of the Roland Park Company, MS 504, Box 292, Special Collections, Sheridan Libraries, Johns Hopkins University; below, records of the Roland Park Company, MS 504, Box 293, Special Collections, Sheridan Libraries, Johns Hopkins University.)

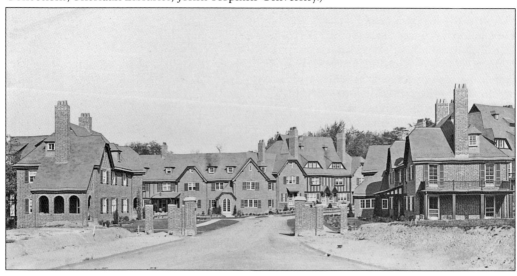

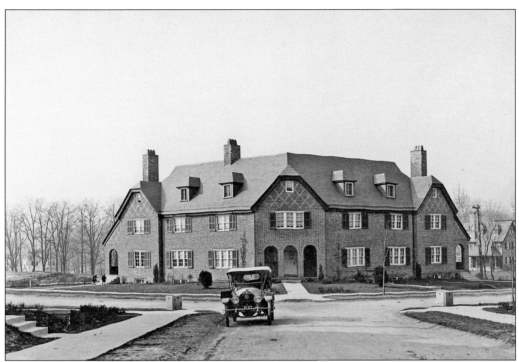

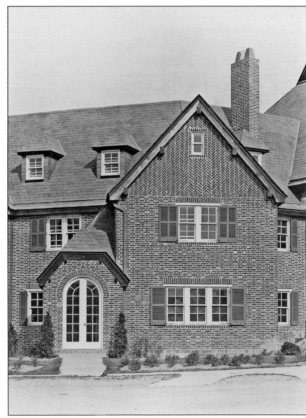

Bretton Place may have started with plans from Standard Buildings Inc., a New York firm specializing in plans for affordable but tasteful housing. Copies of Standard's "workingmen's cottages in the English Style" are preserved in the records of the Roland Park Company at Johns Hopkins University. Much better than Standard's design, Bretton Place eschewed absolute symmetry and employed retrained facades enlivened with elaborate brickwork. A Bretton Place advertisement claims, "The architecture is in the English feeling, and the whole group, with its high pitched roofs and its general sense of enclosure and privacy, will remind you of some nook or corner of the Old World" (*Evening Sun*, June 19, 1914). Bretton Place garnered Palmer national attention. (Both, records of the Roland Park Company, MS 504, Box 293, Special Collections, Sheridan Libraries, Johns Hopkins University.)

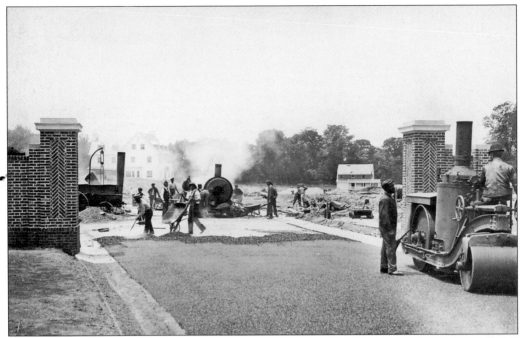

The Roland Park Company built top-quality roads, employing such equipment as a secondhand six-ton double-drive tandem roller from Buffalo Pitts, a manufacturer of steam road rollers. Compare Guilford's smooth roads (above) with the cobblestone surface of York Road (below). The company paved St. Paul Street through Guilford, but the city was responsible for paving up to that point, with predictable results. The city's portion with its "old fashioned 'drop gutter'" had "every appearance of being wretchedly done and [was] entirely inadequate to the demands that w[ould] be put upon it" (*Baltimore Sun*, July 2, 1906). (Below, records of the Roland Park Company, MS 504, Box 293, Special Collections, Sheridan Libraries, Johns Hopkins University.)

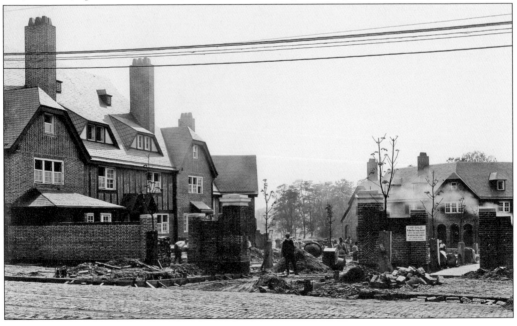

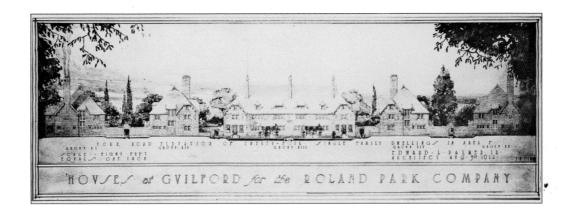

Compare Palmer's preliminary drawings for York Courts (above) with what was actually built (below). York Courts was developed by Downing and Murphy, whose advertisements asks, "Would you like to sit on such a porch overlooking a grassy court, as the evenings grow longer, and take your ease or enjoy a chat with congenial neighbors?" (*Baltimore News*, April 1, 1916). Julian Straughan Downing (1883–1939) is responsible for the (Palmer-approved) final design and took up residence at no. 11 there. The Olmsteds designed the English-style greens around which the three York Courts were built. (Above, records of the Roland Park Company, MS 504, Box 292, Special Collections, Sheridan Libraries, Johns Hopkins University; below, photograph by Weaver, private collection.)

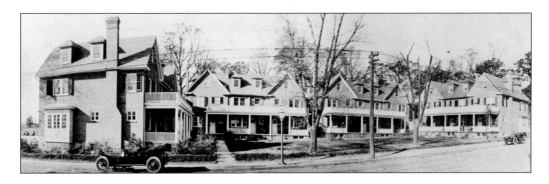

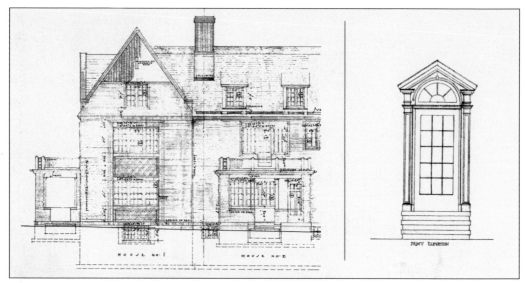

Early construction included additional attached housing on York Road, Newland Road, and Southway. The Newland Road group closest to Bretton Place, designed by Palmer for George Yeatman in 1917, incorporates the architect's hallmark ornamental brickwork (above left). Yeatman was a prolific builder from a family of builders, but this project was one of his very first. Partners Howard Sill, Riggin Buckler, and George Corner Fenhagen designed the remaining Newland Road groups for the Guilford Homes Company in 1919 (above right). The Southway homes, again designed by Palmer for Yeatman, featured columned arcades (left). Dr. Pedro Salinas y Serrano, the renowned Spanish poet, lived on Newland Road. (Above, Roland Park Civic League Collection, University of Baltimore, Langsdale Library, Special Collections; left, photograph by Leopold, courtesy of Kristin Leopold.)

Company president Edward H. Bouton considered "places" in Guilford as early as 1911. Bretton Place sat to the south, York Courts spanned the eastern perimeter, and Norwood Place was one of several northern "places." Just south of Cold Spring Lane, Norwood Place is composed of delightful window-filled cottages designed by Palmer in 1914 and set closely together around a cul-de-sac. Of Guilford's northern "places," Frederick Law Olmsted Jr. wrote on December 13, 1911, "I need hardly cite the popularity of the 'no fence' campaigns in many suburban localities . . . I am not much in love with that point of view myself, but if it is good anywhere it is good in a 'place.'" (Both, records of the Roland Park Company, MS 504, Box 293, Special Collections, Sheridan Libraries, Johns Hopkins University.)

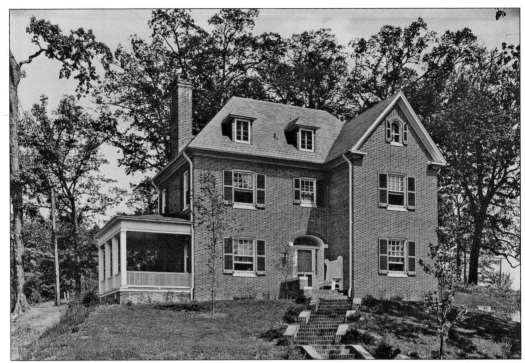

Palmer designed several smaller homes for the company early in the development of Guilford, especially in the southeastern quadrant. Examples of Palmer's smaller commissions include a brick home for attorney A. Morris Tyson at Chancery Road and Southway (above) and a stucco residence on Charlcote Road designed in the spring of 1913 for Allan MacSherry, another lawyer (below). (Both, records of the Roland Park Company, MS 504, Box 293, Special Collections, Sheridan Libraries, Johns Hopkins University.)

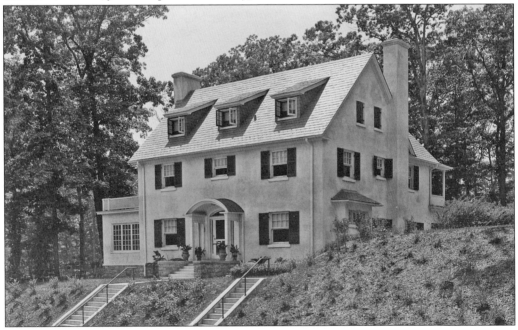

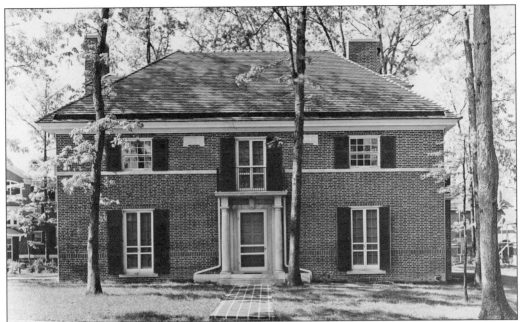

Palmer's larger Guilford projects include an early brick home on Charlcote Place for Dr. Joseph Sweetman Ames (1864–1943), a professor of physics who became president of Johns Hopkins University. Ames was a founding member of the National Advisory Committee for Aeronautics (the predecessor to NASA) and served as chairman for two decades. The NASA Ames Research Center was named in his honor. The restrained facade is ornamented with stone columns flanking the entrance and two decorative plaques of classical design (above). The home has a second-story sleeping porch, and the third-floor windows are shown with the once ubiquitous canvas awnings (below). (Both, records of the Roland Park Company, MS 504, Box 295, Special Collections, Sheridan Libraries, Johns Hopkins University.)

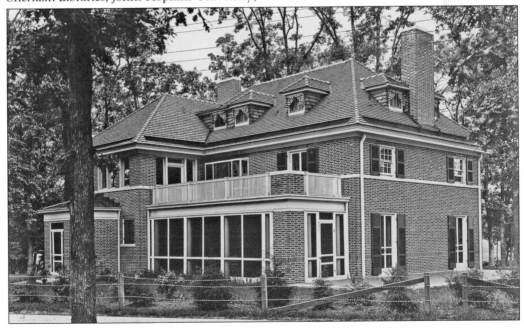

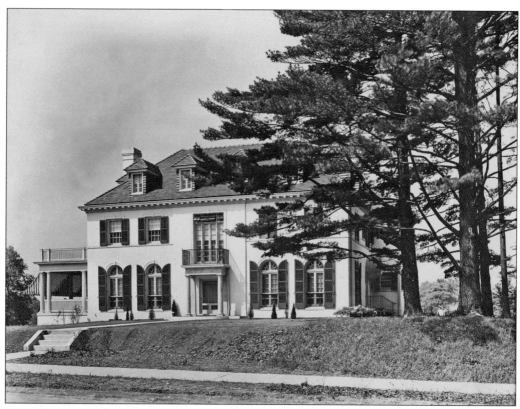

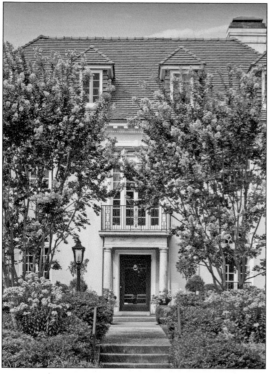

Palmer designed an Italian Renaissance Revival stucco home on Greenway for Daniel C. Ammidon, a tin-roofing manufacturer. Ammidon also served on the Baltimore City Board of Police Commissioners from 1914 to 1916. Tall arched windows express the modern concern for increased light and air. The home is shown shortly after it was built (above) and as it appears today with mature landscaping (left). Construction was completed in the fall of 1914. (Above, records of the Roland Park Company, MS 504, Box 295, Special Collections, Sheridan Libraries, Johns Hopkins University; left, Greg Pease Photography.)

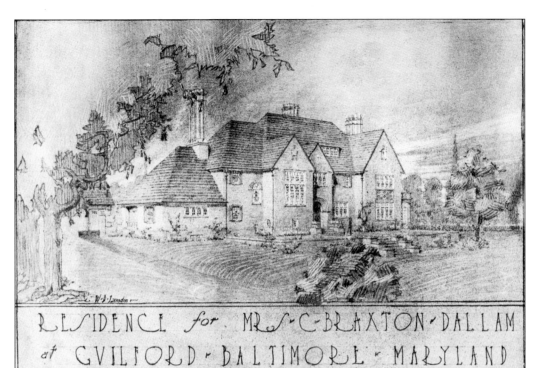

RESIDENCE for MRS. C. BRAXTON DALLAM at GUILFORD - BALTIMORE - MARYLAND

The grand brick Tudor Revival residence commissioned by Corbin Braxton Dallam on Greenway is one of Palmer's best-known projects. Dallam was associated with the oil company William C. Robinson and Son and the Commercial Credit Company (now part of Citigroup). Dallam was also an accomplished gardener and rosarian. The Dallams acquired a large parcel to accommodate an important home and well-developed grounds. Finishes included coffered oak ceilings, a fireplace incorporating Moravian tile, and wall sconces. This drawing of the Dallam home (above), known as the Guilford House, shows the front elevation. The home was completed by 1916. Here, four generations gather in the Dallam garden (right). (Above, records of the Roland Park Company, MS 504, Box 294, Volume 2, Special Collections, Sheridan Libraries, Johns Hopkins University; right, private collection.)

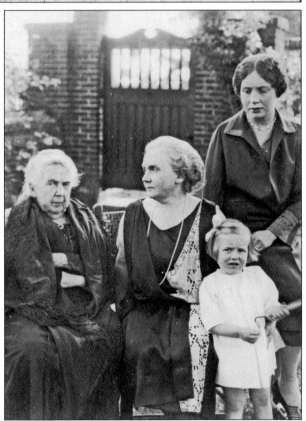

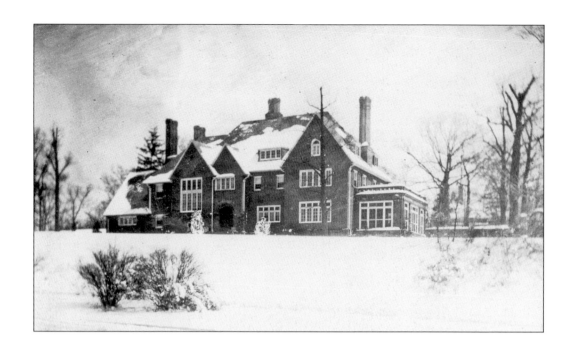

The Guilford House sits back from the street and runs the length of the block. From the street, one can see the refined, spare facade with banks of windows and decorative chimneys. The garden view (below) offers a better look at the home. Here, one can appreciate the beauty of the chimneys and see the porches. The grounds once included an apple orchard and prized rose garden. (Both, private collection.)

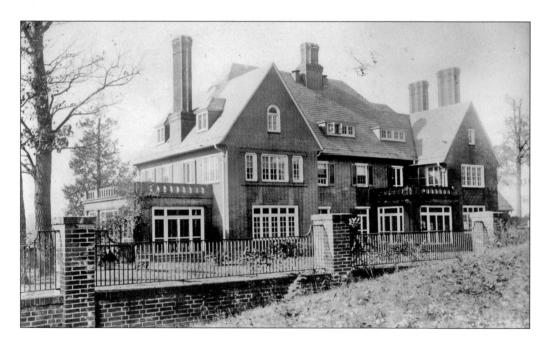

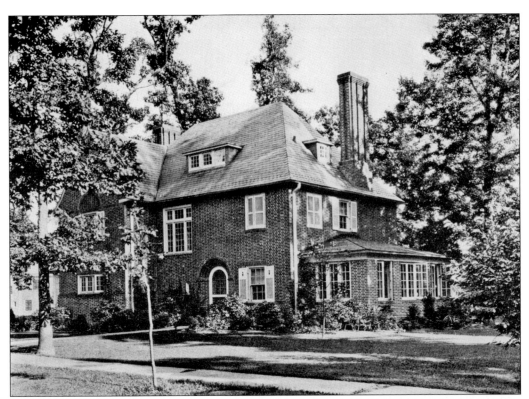

William Graham Bowdoin Jr., son of a prominent banker, may have commissioned this Tudor Revival home but never took up residence. The facade is spare, with the arched brick doorway surround and chimneys comprising the main adornments. The garden view had double-bay casement windows and ivy-clad lattice. The land was purchased by 1915 and the home completed around 1918. Bowdoin's two sisters both married prominent medical men and also moved to Guilford. Marion Gordon married Dr. James Hall Mason Knox Jr., and Katherine Gordon married Dr. John Staige Davis, a pioneering plastic surgeon. The two sisters and their respective families built homes on adjacent Wendover Road lots just a few blocks from their brother. (Both, courtesy of Fernando Pineda.)

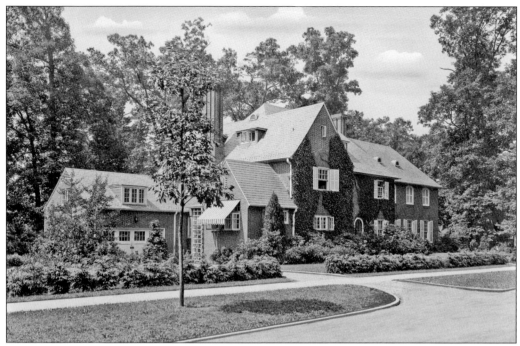

Paul Chenery Patterson, president of the *Baltimore Sun*, and his wife, the former Elsie Jarvis McLean, expanded the home in 1925. The addition is visible on the far right (above). The residence features random-width oak-peg floors, a sunken library, and a pine-paneled dining room (below). (Above, records of the Roland Park Company, MS 504, Box 286, Special Collections, Sheridan Libraries, Johns Hopkins University; below, photograph by A. Aubrey Bodine. *Gardens, Houses and People* 1933 © Enoch Pratt Free Library, Maryland's State Resource Center. All Rights Reserved. Used with permission. Unauthorized reproduction or use prohibited.)

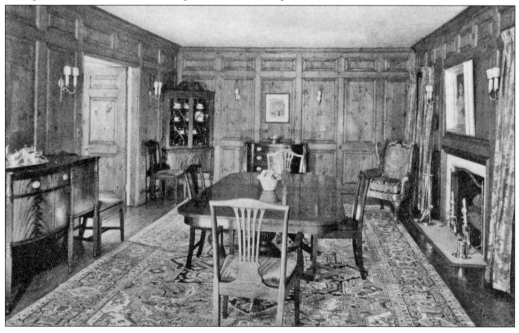

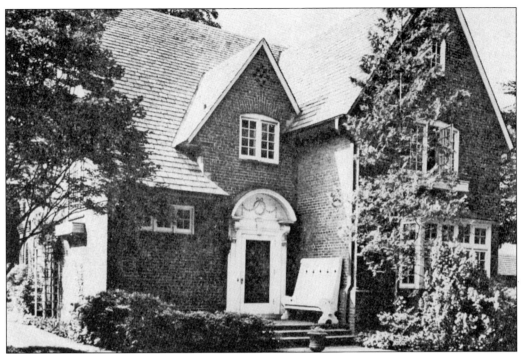

Palmer's partner, William D. Lamdin, was responsible for several Guilford projects, including this Chancery Road home close to Palmer's Chancery Square. James Woodell Kenny appears to have purchased the lot by 1915, and the home was built shortly thereafter. The brick residence features casement windows, bay windows, and charming window boxes. (Above, *Gardens, Houses and People* 1950 © Enoch Pratt Free Library, Maryland's State Resource Center. All Rights Reserved. Used with permission. Unauthorized reproduction or use prohibited; below, photograph by the author.)

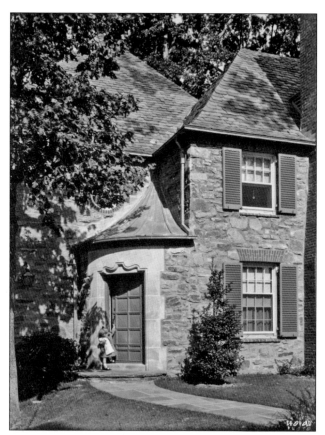

Lamdin is widely admired for these two Norman Revival homes, built during his partnership with Palmer. Both homes employ variegated stone, steeply pitched slate roofs, and striking brick chimneys. The Underwood Road home (left) belonged to George M. Engler. The poet Ogden Nash and his wife rented this home before moving to Rugby Road (see page 68). Seymour Ruff and Sons did the stonework using locally quarried stone. The Greenway home (below) was occupied by Rev. Harold Noel Arrowsmith and his wife, the former Frances Swayne Cook. Reverend Arrowsmith served as canon for the Episcopalian cathedral from 1916 to 1951. When appointed, he was canon-in-charge; the cathedral had not yet been completed. (Left, photograph by Leopold, courtesy of Kristin Leopold; below, photograph by a *Baltimore Sun* staff photographer, courtesy of the *Baltimore Sun*.)

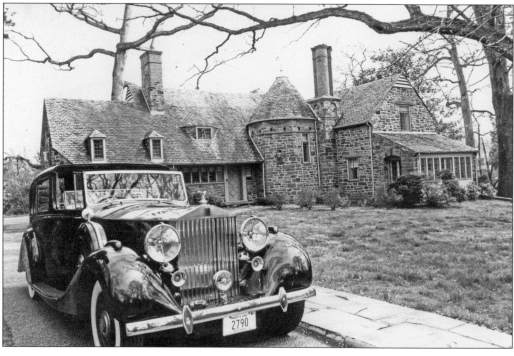

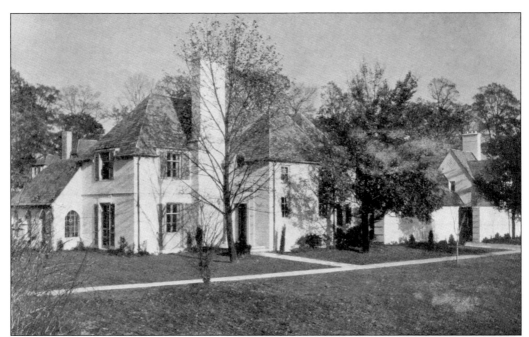

Of the many fine Palmer and Lamdin commissions in Guilford, the Gateway Houses are most venerated. Bracketed by the Little Park to the north and Guilford Gateways (known as Gateway Park) to the south, it is possible to admire the homes on all sides. The Gateway Houses consist of paired homes in the French Country style sharing a garage and service court. Similar in feeling, but not identical, the rosy-hued brick homes have steeply pitched roofs of graduated slate and windows in various shapes and sizes. In 1927, the homes were painted white (above). The St. Paul Street home has a loggia overlooking the Little Park. The contemporary photograph (right) shows a detail of that loggia. (Above, photograph by Holmes I. Mettee, the *Roland Park Company's Magazine* 1927 © Enoch Pratt Free Library, Maryland's State Resource Center. All Rights Reserved. Used with permission. Unauthorized reproduction or use prohibited; right, Brian P. Miller Photography.)

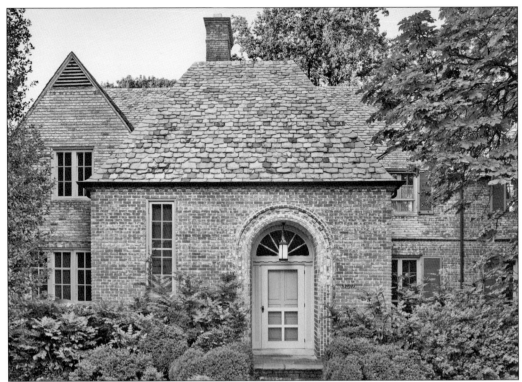

The Gateway Houses were designed for two merchant brothers, Marion Oldham and William Graham Lewis. The homes were completed in the 1920s, but the gates, garden wall, and pool were added piecemeal through 1930. Most sources attribute the Gateway Houses to Lamdin, but this project certainly bears Palmer's imprint. The harmonious, balanced architectural treatment eschewing symmetry, the masterful use of ornamental brickwork, especially around doorways, and the outdoor loggia—these are all Palmer hallmarks. The homes today have been stripped of their paint, revealing beautiful soft-pink brick. (Both, Greg Pease Photography.)

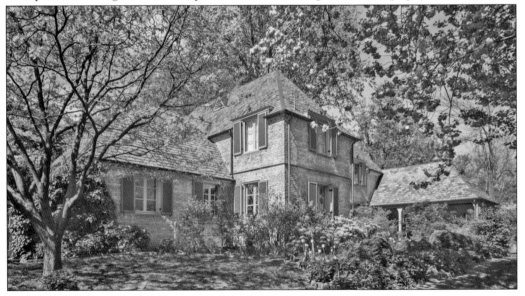

Four

"A MAN OF EXPERIENCE AND DISCRIMINATION"

Laurence Hall Fowler (1876–1971) was not one of the architects initially selected to advise the company on plans for Guilford. In 1912, Fowler was, if not quite newly minted, still building his practice. Despite a classical training emphasizing monumental projects, the upward arc of Fowler's career overlapped with the development of Guilford. Fowler did attain monumental commissions, including the war monument building in Baltimore (1921) and the Hall of Records in Annapolis (1934), but he is remembered primarily for his residential work.

After graduating from Johns Hopkins University in 1898, Fowler attended Columbia University during the tenure of William Robert Ware, where he studied venerated examples of ancient and medieval architecture. Following his graduation from Columbia in 1902, Fowler worked for two New York firms in quick succession. He worked first for Maryland-native Bruce Price (1845–1903), known for Tuxedo Park (1885), an influential New Jersey project featuring geometric Shingle Style cottages designed to harmonize with the surrounding woodlands. Fowler then went to William Alciphron Boring (1859–1937) and Edward Lippincott Tilton (1861–1933), who had both studied at l'École des Beaux-Arts and worked at the firm of McKim, Mead & White. Boring had also studied at Columbia under Ware and would later become director and then dean of the Columbia School of Architecture. Tilton specialized in libraries and enjoyed Carnegie commissions.

Fowler traveled through Italy and France and joined the atelier Godefroy and Freynet to prepare for l'École des Beaux-Arts; he was admitted but did not continue his classical training. He returned instead to Baltimore and soon entered private practice. In 1911, Fowler received his first large commission near Guilford. Fowler's homes are frequently compact, highly geometric, restrained, and concerned with matching design to site conditions. Fowler served on the Roland Park Company Architectural Review Board from 1927 to 1935 and also advised university officials concerning the building plan at Johns Hopkins University's Homewood campus. A scholar and early preservationist, Fowler was in eyes of his peers "a man of experience and discrimination" (see page 58).

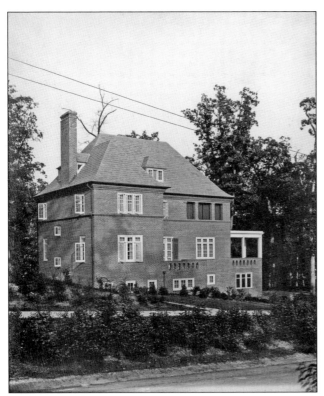

Fowler designed this brick Charlcote Road home in 1913 for John Edward Semmes Jr., a lawyer at Semmes, Bowen & Semmes, connected with the Roland Park Company. The residence is compact, square, and features a steeply pitched roof, banks of casement windows, and porches, including a second-story sleeping porch. The use of exterior ornamentation is minimal, and the home nestles into the sloping terrain. (Both, Laurence Hall Fowler Papers MS 413, Series 7, Box 1, Special Collections, Sheridan Libraries, Johns Hopkins University.)

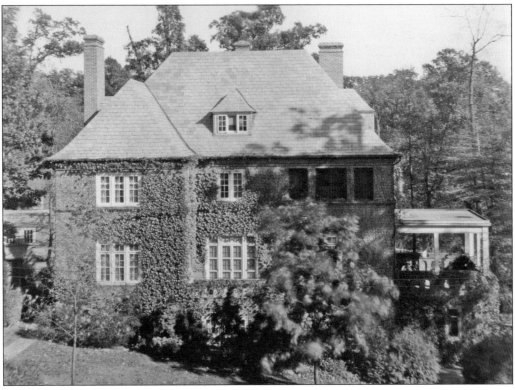

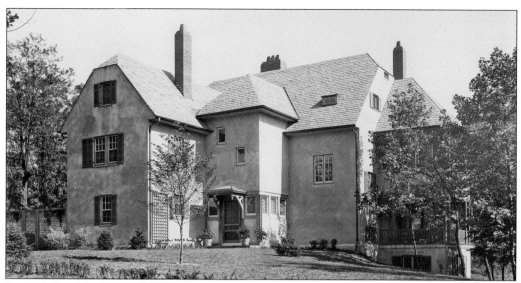

In 1913, Dr. John Boswell Whitehead commissioned Fowler to design a stucco home on Cold Spring Lane. Whitehead was an electrical engineer who became the director of the Johns Hopkins University School of Engineering, which he helped to establish. The university's Whitehead Hall was named in his honor. The facade is largely unadorned save for the bracketed entrance, several diamond-paned windows, and a bit of lattice (above). The rear (below) offers a better view of the porches and glass-paned doors on the garden side. (Above, Hughes Company Glass Negative Collection, the Photography Collections, University of Maryland, Baltimore County; below, Laurence Hall Fowler Papers MS 413, Series 7, Box 1, Special Collections, Sheridan Libraries, Johns Hopkins University.)

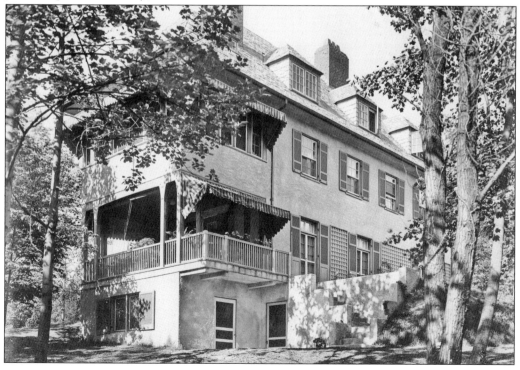

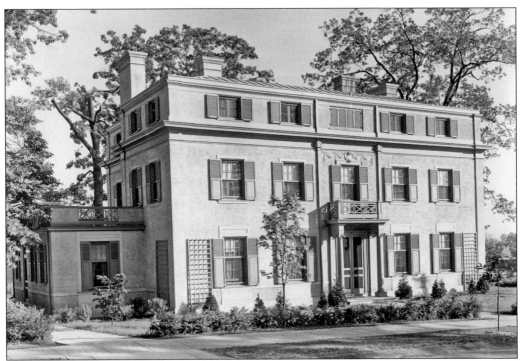

This stucco Wendover Road home was another 1913 Fowler commission. Designed for Thomas Goodwillie, general manager for the Baltimore Division of the Standard Oil Company, the home has four chimneys and is highly symmetrical in its plan. The garden view (below) shows a columned rear portico bookended with bay windows, loggia, lattice, and matching fencing. (Both, Laurence Hall Fowler Papers MS 413, Series 7, Box 2, Special Collections, Sheridan Libraries, Johns Hopkins University.)

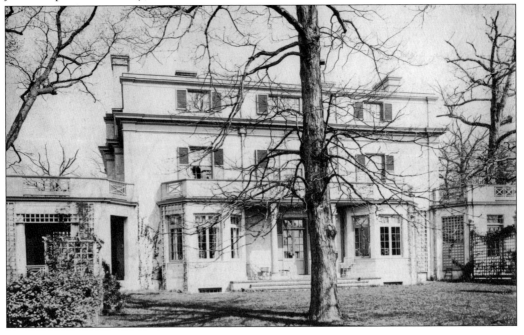

In 1914, Fowler designed his second stucco home on Wendover Road. This residence was built for William Amos Dixon. Dixon was president of the Dixon-Bartlett Company, a boot and shoe manufacturer that had lost $175,000 worth of property in the Great Fire of 1904. The garden view (below) shows multipaned glass doors, with transoms, leading into the garden. Fowler added the projecting bay four years later. (Both, Laurence Hall Fowler Papers MS 413, Series 7, Box 2, Special Collections, Sheridan Libraries, Johns Hopkins University.)

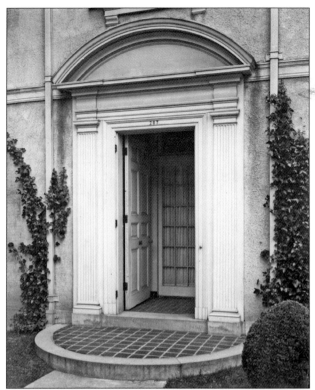

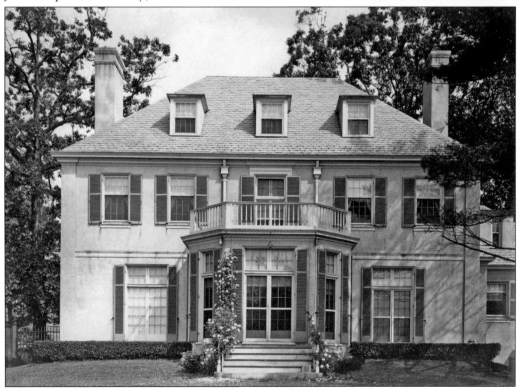

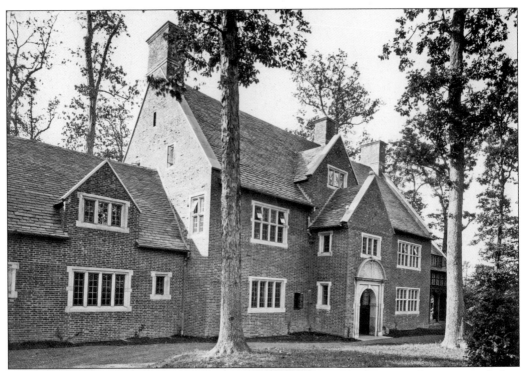

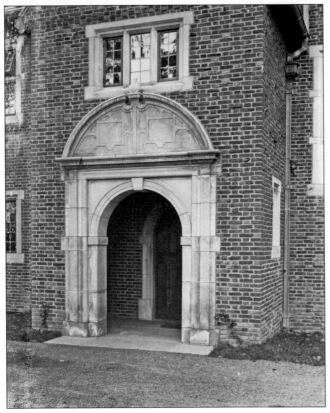

Fowler enjoyed two particularly well-funded commissions in Guilford. The first of these was a Warrenton Road commission for Harry Crawford Black and his wife, the former Constance Hoffmeister, in 1919. After his brother Van Lear Black was lost at sea in 1930, Black took his place as chairman of the A.S. Abell Company, publisher of the *Baltimore Sun*. He also served as chairman of the A.S. Abell Company Foundation, now simply the Abell Foundation. This grand residence has a brick facade, steeply pitched roof, and tall metal-sashed casement windows imported from England. The garage is incorporated into the house. (Both, Laurence Hall Fowler Papers MS 413, Series 7, Box 5, Special Collections, Sheridan Libraries, Johns Hopkins University.)

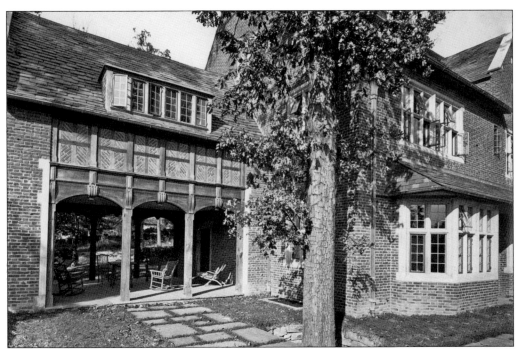

Constance Black had English roots and may have been inspired by the large Tudor manse belonging to her mother, Helen Cosway. Both Constance and her mother were active fundraisers during World War II. Her mother dug a garden in England at her estate, and Constance followed suit in Baltimore. Proceeds of cut flowers, plants, and vegetables raised in the Guilford garden were divided between the US Navy Relief and the British Air Raid Relief. (Both, Laurence Hall Fowler Papers MS 413, Series 7, Box 5, Special Collections, Sheridan Libraries, Johns Hopkins University.)

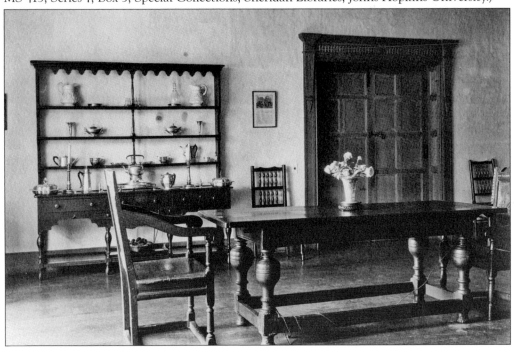

In 1925, Fowler designed this Stratford Road home for Theodore Klein Miller Jr., whose family business, the Daniel Miller Company, was one of the largest dry-goods wholesalers in the South. The Millers requested a Spanish Colonial Revival home in the manner of Addison Cairns Mizner (1872–1933). In 1926, architect Harold Appleton Stilwell (1888–1956) submitted plans for a home on Underwood Road employing the same style. The Architectural Review Board, which included Fowler himself, responded harshly: "The house is designed in the Spanish style which is foreign to Baltimore . . . and . . . should be made by a man of experience and discrimination. Neither of these qualities [is] indicated on the drawings submitted." Stillwell was advised to study the Miller house. The view of the dining room (below) shows garden-side French doors. (Both, photograph by William L. Klender, courtesy of the *Baltimore Sun*.)

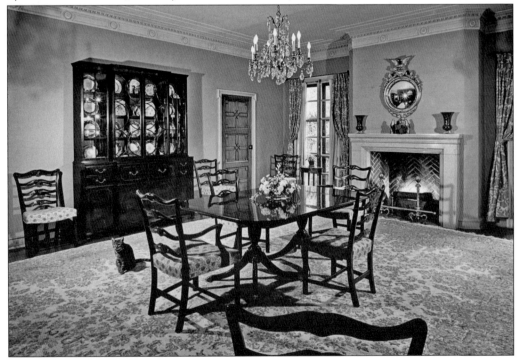

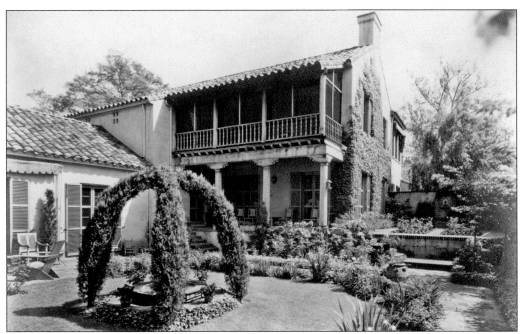

The garden view shows the veranda colonnade and well-developed garden. One early owner was John Macy Willis, vice president and general manager of the Bethlehem Fairfield Shipbuilding Company, dubbed the "world's greatest shipbuilder" for his wartime work. One of the ships launched during Willis's tenure was the SS *Arunah S. Abell*. Gerald S. Wise, general manager of Baltimore-area Sears, Roebuck and Co. stores, also lived in the home. Wise served as president of the Guilford Association. His wife, Louise Berry Wise, is shown standing in the garden in the photograph below. (Above, photograph by Holmes I. Mettee, Laurence Hall Fowler Papers MS 413, Series 7, Box 19, Special Collections, Sheridan Libraries, Johns Hopkins University; below, photograph by William L. Klender, courtesy of the *Baltimore Sun*.)

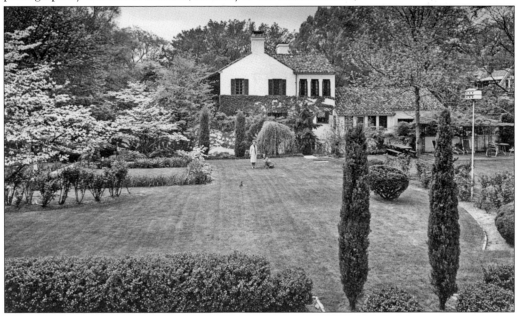

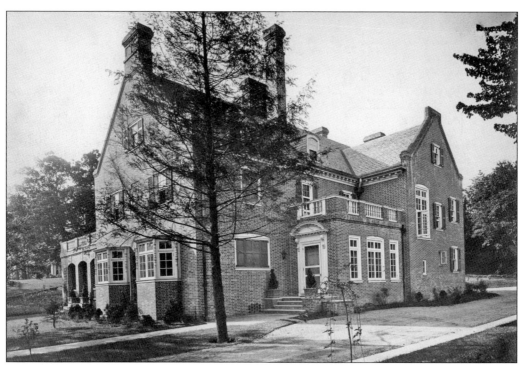

Fowler designed a number of homes on Guilford's western perimeter. The first was this brick home for the Shiff sisters located on Thirty-ninth Street. Named the Ascot House, the residence had bay windows, ornamental chimneys, and columned loggia. The photograph at left offers a better view of the chimneys and bay windows and also shows some of the restrained ornamental brickwork. (Both, Laurence Hall Fowler Papers MS 413, Series 7, Box 1, Special Collections, Sheridan Libraries, Johns Hopkins University.)

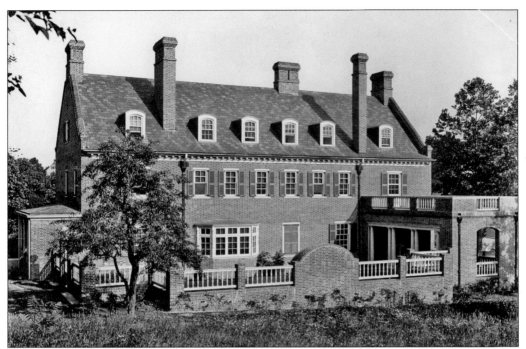

Fowler's design for the Ascot House included a brick garden wall. The view from the loggia into the garden (below) shows a pretty garden bench built into this wall. Ascot House was a fine residence, but sadly this home was demolished. All of Fowler's Guilford commissions survive, but time has not been kind to the many fine homes like the Ascot House, which were built near, but not within, the Guilford development. (Both, Laurence Hall Fowler Papers MS 413, Series 7, Box 1, Special Collections, Sheridan Libraries, Johns Hopkins University.)

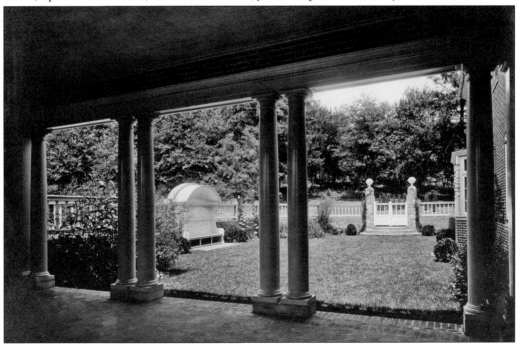

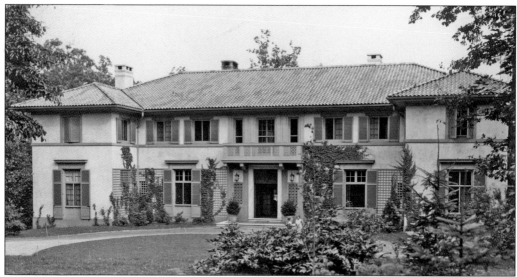

Oak Place was a small development adjacent to Guilford. Dr. William Bullock Clark purchased the land and commissioned Fowler to design this home known as Oak Place in 1914. Clark headed the Department of Geology at Johns Hopkins University and founded and directed both the Maryland Weather Service and the Maryland Geological Survey. Oak Place was later home to Dr. Isaiah Bowman during his tenure as president of Johns Hopkins University. Bowman was director of the American Geographical Society and the chief territorial specialist for the American delegation to the Paris Peace Conference (1918–1919) at Versailles. The American Geographical Society's Bowman Expeditions are named in his honor. (Both, Laurence Hall Fowler Papers MS 413, Series 7, Box 2, Special Collections, Sheridan Libraries, Johns Hopkins University.)

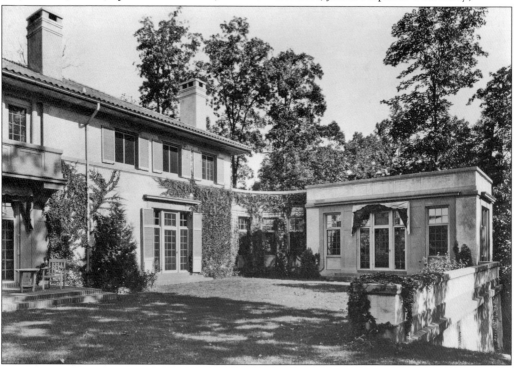

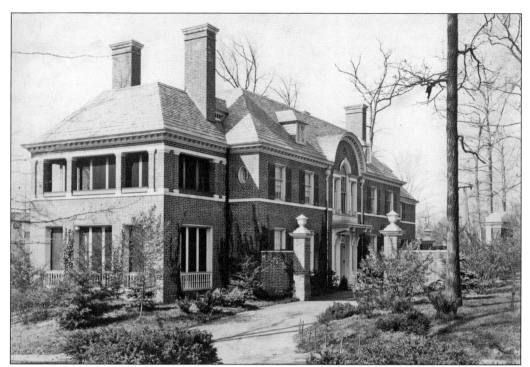

The precise location of Oak Place is difficult to describe, but in a June 1931 edition of *Gardens, Houses and People*, someone gives it a try: "[Oak Place] is on the straight stretch made by Charles Street after it turns its back, in its course to the east, on Greenway to run along for several blocks for a turn close to Warrenton Road that carries it through the western part of Guilford." Additional homes built on this site include Fowler's Oak Place One, designed in 1916 for three of his cousins (shown here), and Oak Place Two designed for John Howland. The residence designed for his cousins had a symmetrical plan, grand front entrance with a Palladian window, and a second-story sleeping porch. The photograph at right offers a detail of the front entrance. (Both, Laurence Hall Fowler Papers MS 413, Series 7, Box 3, Special Collections, Sheridan Libraries, Johns Hopkins University.)

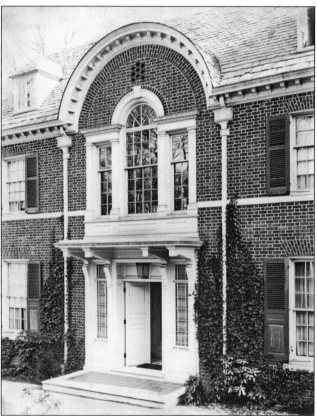

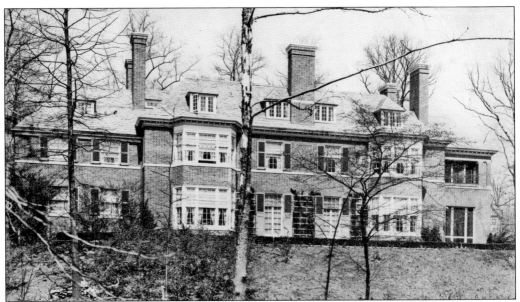

Oak Place One featured bay windows on the rear elevation (above) and classical details in the interior (below). In 1931, the Roland Park Company announced that Clark's widow had "turned over the development of [Oak Place] to the Company. . . Restrictions similar to those that prevail elsewhere in The District have been adopted, so that Oak Place will be a part of Guilford not only intrinsically but, as it were, in spirit as well" (*Gardens, Houses and People*, June 1931). Yet Oak Place as a development did not survive. One of the homes was absorbed into Calvert School, and most of the others were cleared away for development. (Both, Laurence Hall Fowler Papers MS 413, Series 7, Box 3, Special Collections, Sheridan Libraries, Johns Hopkins University.)

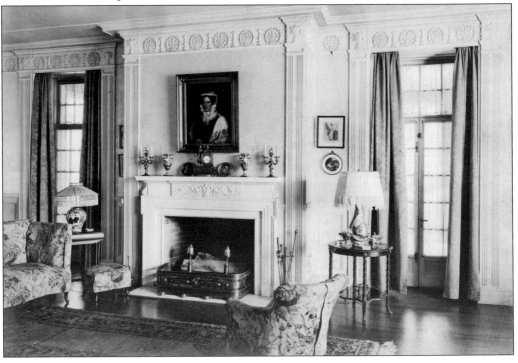

Five

"A DIFFICULTY OF GREAT MAGNITUDE"

The development of Guilford marked a departure for the Roland Park Company. The company had three architectural objectives for their newest development. First, the company sought "a consistent and harmonious development of the entire property" (*Baltimore Sun*, February 17, 1912). Second, Guilford was to choreograph luxury and taste yet provide affordable homes. Third, Guilford had to integrate with the monumental development planned next door. The Roland Park Company had big expectations and a compressed time frame.

In 1912, company officials invited leading architects to a luncheon and roundtable session at the Baltimore Country Club in Roland Park. The firms of Grosvenor Atterbury, then overseeing Forest Hills Gardens; Baldwin and Pennington; Ellicott and Emmart; Glidden and Friz; Owens and Sisco; Parker, Thomas & Rice; Howard Sill; J. Evans Sperry; Bayard Turnbull; Wyatt and Nolting; and John Appleton Wilson were represented at that meeting. In a letter sent to Wyatt and Nolting in January 1912, Bouton outlines the challenges:

> In a building operation of this kind, where a large measure of individuality in the designs of the various buildings is to be expected (and is desired) it is unavoidable that the many complexities connected with their erection should present a difficulty of great magnitude . . . The proper development of Guilford is, it seems to us, a work of public importance, the successful outcome of which should mean much not only to the general interests of the City, but in an especial sense to the development of its domestic architecture. (Records of the Roland Park Company, MS 504, Box 260, Special Collections, Sheridan Libraries, Johns Hopkins University.)

Attendees considered eight questions concerning architecture at Guilford. Their responses would "form the basis for a consistent and harmonious development of the entire property" (*Baltimore Sun*, February 17, 1912).

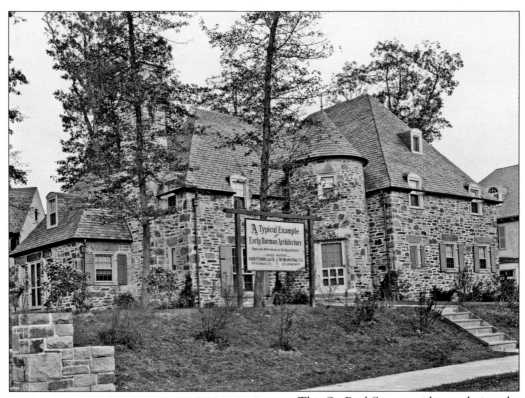

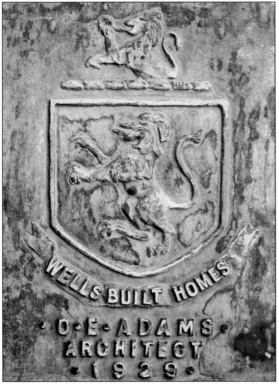

This St. Paul Street residence, designed by Otto Eugene Adams (1889–1968), is promoted on the sign pictured as "a typical example of early Norman architecture" by the builder, Clifton K. Wells Jr. Advertisements described "a home of impressive beauty—a home of permanent satisfaction to the owner" and promised that a "complete garden with fountain, walks, sun-dial, and arbors, laid out by a landscape architect, will be included," according to an article in the May 1929 edition of *Roland Park Company's Magazine*. The residence had a turret, round entrance hall, walnut-paneled living room, library and book alcove, a basement clubroom and kitchenette, and a plaque inscribed with the architect's name (left). The home sold to physician Dr. Henry Lee Smith. (Above, BGE Collection at the Baltimore Museum of Industry; left, photograph by the author.)

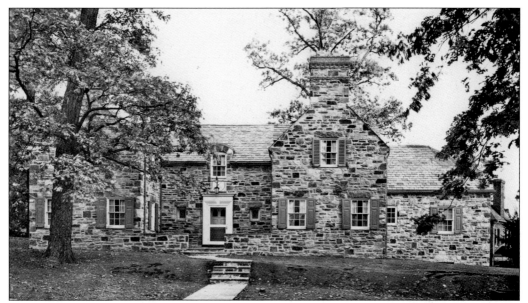

John Ahlers (1895–1983) became the company's supervising architect in 1935. His commissions include these homes from the 1930s. The stone Greenway residence (above) built by Thomas Hicks and Sons was home to aviation pioneer Glenn Luther Martin. Following several mergers, Martin's company became Lockheed Martin Corporation, the world's largest defense contractor. The whitewashed brick home on St. Paul Street, dubbed "the House of Tomorrow" (below), was built for famed embryologist Dr. George Linius Streeter and his wife, the former Julia Allen Smith, by the F.E. Wurtzbacher Corporation. The home incorporates ornamental brick, decorative ironwork, and glass block. (Above, photograph by Leopold, records of the Roland Park Company, MS 504, Box 286, Special Collections, Sheridan Libraries, Johns Hopkins University; below, photograph by a *Baltimore Sun* staff photographer, courtesy of the *Baltimore Sun*.)

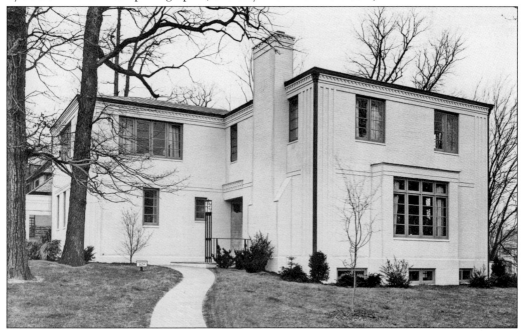

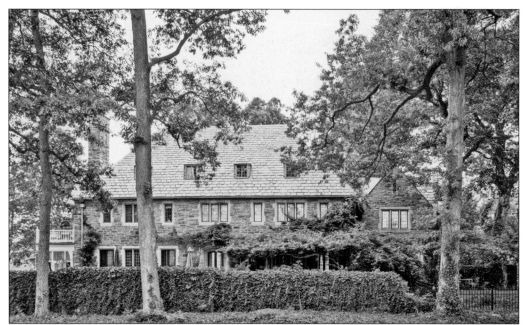

Riggin Buckler (1882–1955) and George Corner Fenhagen (1884–1955) were longtime partners. Their firm was founded as Sill, Buckler & Fenhagen (see page 38), but Howard Sill left for private practice in 1921. This stone home was built in 1927 for William Wirt Leonard and his wife, the former Nellie McBride Jackson, daughter of Maryland governor Elihu Emory Jackson. The living room (below) incorporated an Adams mantel from England and colonial cornice from the Eastern Shore. Their daughter Frances married the poet Ogden Nash, and the couple later resided here. (Above, Greg Pease Photography; below, *Gardens, Houses and People* 1932 © Enoch Pratt Free Library, Maryland's State Resource Center. All Rights Reserved. Used with permission. Unauthorized reproduction or use prohibited.)

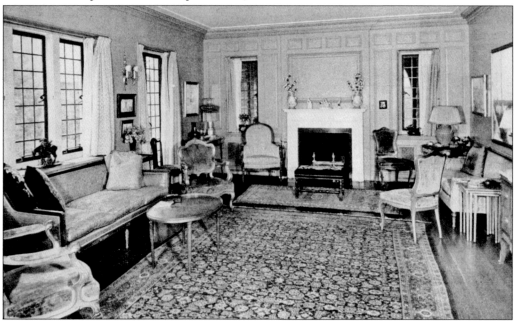

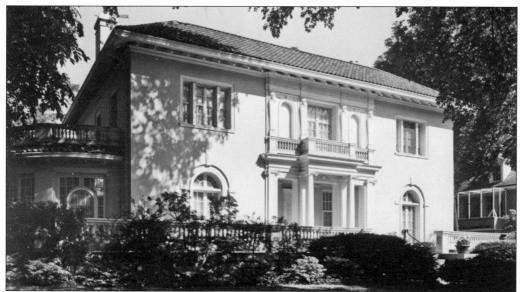

William Miller Ellicott III (1863–1944) and William Wirt Emmart (1869–1949) were active in Roland Park, where they designed residences as well as the Woman's Club of Roland Park (1901) and St. David's Episcopal Church (1907). In Guilford, they are responsible for this stucco and tile-roofed Bishops Road home for Carl G. Hilgenberg. Hilgenberg was the president of the Carr-Lowrey Glass Company, which specialized in perfume and pharmaceutical bottles. Milton Stover Eisenhower, shown in the living room (below), also resided here. Eisenhower served as president of three universities, including Johns Hopkins University. He was also an advisor to three presidents—his brother Dwight D. Eisenhower, John F. Kennedy, and Lyndon B. Johnson. Johns Hopkins University's Milton S. Eisenhower Library was named in his honor. (Both, photograph by A. Aubrey Bodine, courtesy of the *Baltimore Sun*.)

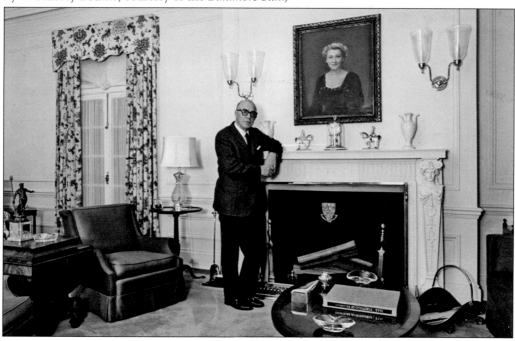

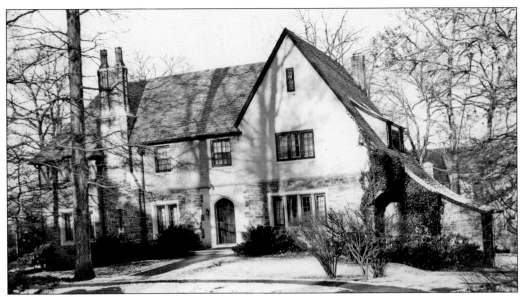

Dating to 1926, this stucco, stone, and brick Charlcote Place residence is the work of Clyde Nelson Friz (1867–1942) and his son Nelson Friz (1906–1963). The prizewinning garden of homeowner Louise McPhail (below) had "the effect of being sunken, the pool being directly in front of the steps leading up to the house . . . it offers kingfishers, *en passant*, a temptation too alluring to be resisted, even by birds of far stronger moral convictions" (*Gardens, Houses and People*, November 1931). (Above, photograph by Leopold, records of the Roland Park Company, MS 504, Box 286, Special Collections, Sheridan Libraries, Johns Hopkins University; below, *Gardens, Houses and People* 1931 © Enoch Pratt Free Library, Maryland's State Resource Center. All Rights Reserved. Used with permission. Unauthorized reproduction or use prohibited.)

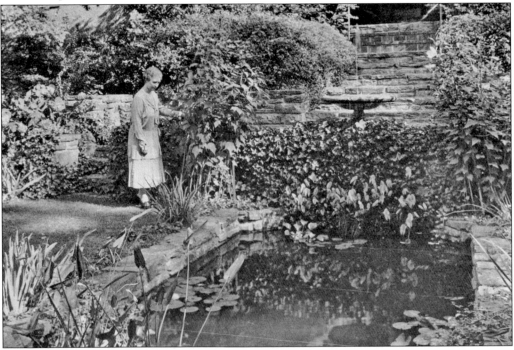

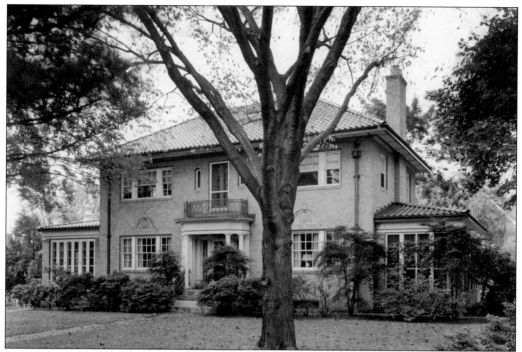

Walter Max Gieske (1883–1926) designed this brick and tile-roofed St. Paul Street home in 1926 for Dr. Waitman Farnsworth Zinn, a physician and throat expert. John Hiltz and Sons were the builders. The Architectural Review Board requested changes but resigned itself to the buff-colored brick. Edward L. Palmer Jr. helped Gieske with revisions. The two small arched windows were something of a compromise. (Both, photograph by Leopold, records of the Roland Park Company, MS 504, Box 286, Special Collections, Sheridan Libraries, Johns Hopkins University.)

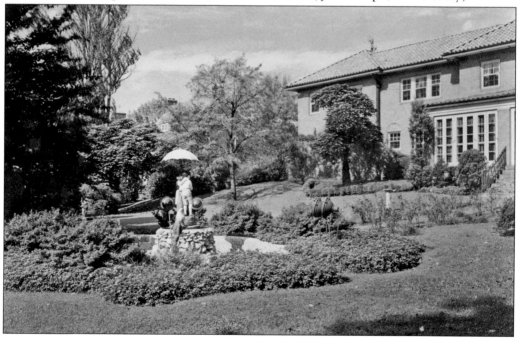

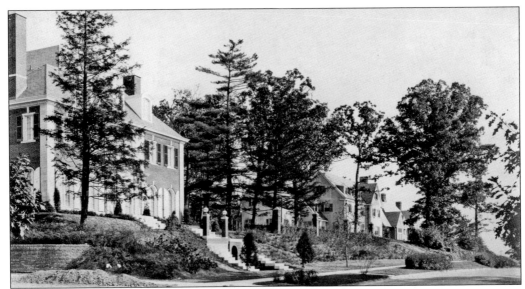

Edward Hughes Glidden Sr. (1873–1924) designed a French Renaissance Revival Greenway residence (above left) for William Francis Cochran Jr. Cochran's wealth derived from the Alexander Smith and Sons Carpet Company, established in 1865 in Yonkers, New York, and now preserved as the Alexander Smith Carpet Mills Historic District. He developed Sherwood Forest, a summer retreat in Maryland's Anne Arundel County, advertised as "Just as Exclusive Half as Expensive." Cochran supported the Anti-Saloon League. Known now as Il Palazzetto (the Little Palace), the residence had a Palladian entrance, split stair (below), walled garden, and ballroom-sized entry hall—but no wine cellar. (Above, records of the Roland Park Company, MS 504, Box 286, Special Collections, Sheridan Libraries, Johns Hopkins University; below, photograph by a *Baltimore Sun* staff photographer, courtesy of the *Baltimore Sun*.)

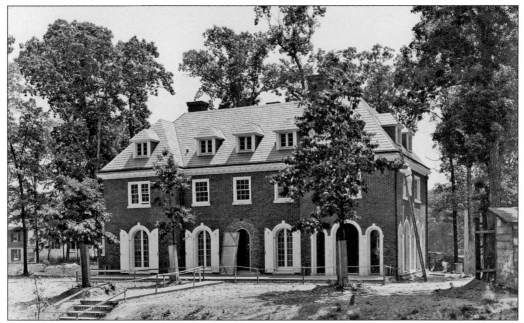

Glidden Sr. is also responsible for the Greenway home commissioned by prominent coal exporter Charles W. Hendley. The large brick home has an arched and columned front entrance and arched French doors, many of them Palladian. Here, one sees the home nearing completion (above) and finished with landscaping around 1914 (below). (Above, records of the Roland Park Company, MS 504, Box 293, Special Collections, Sheridan Libraries, Johns Hopkins University; below, records of the Roland Park Company, MS 504, Box 295, Special Collections, Sheridan Libraries, Johns Hopkins University.)

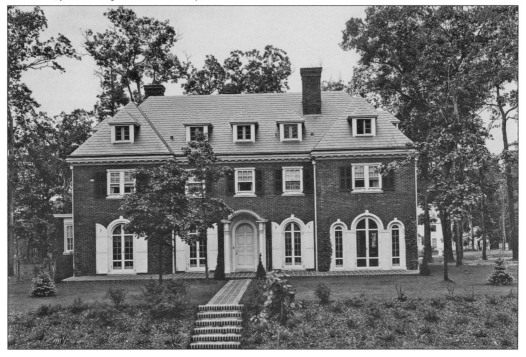

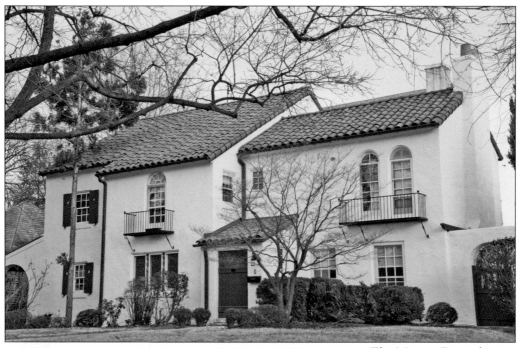

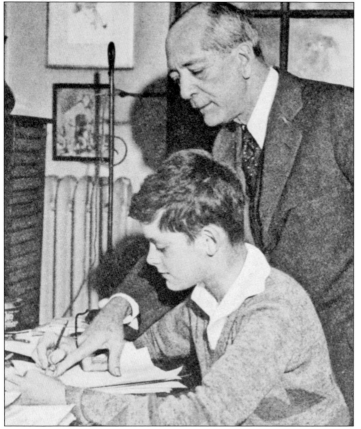

The Mission Revival home of Fredrick Arnold Kummer on St. Martins Road is the work of Edward Hughes Glidden Jr. (1901–1975). Kummer was a published author and successful playwright. Kummer is pictured at left with his son Joseph in the study. (Above, photograph by the author; left, *Gardens, Houses and People* 1933 © Enoch Pratt Free Library, Maryland's State Resource Center. All Rights Reserved. Used with permission. Unauthorized reproduction or use prohibited.)

Thomas Gresham Machen (1886–1975) and David Ellsworth Dixon (1894–1961) designed this Warrenton Road home for Edgar Davis Edmonston, superintendent of electrical operations for the Consolidated Gas and Electric Company. Entrance hall wallpaper copied a design from the Paul Revere House in Boston attributed to Sir Christopher Wren. (Photograph by Leopold, records of the Roland Park Company, MS 504, Box 286, Special Collections, Sheridan Libraries, Johns Hopkins University.)

Bank president J. Harry West's Greenway home was the work of George Norbury MacKenzie III (1875–1928). Built around 1920, the home used Gwynns Falls stone. Seymour Ruff and Sons did the stonework. West also served as president of the Guilford Association. (Private collection.)

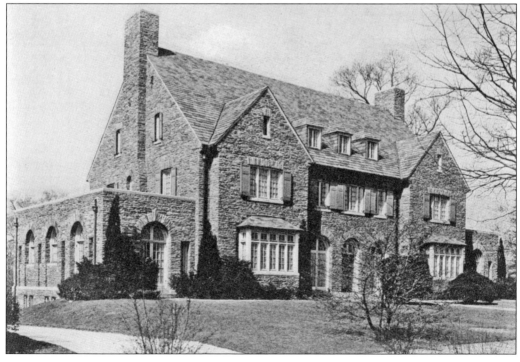

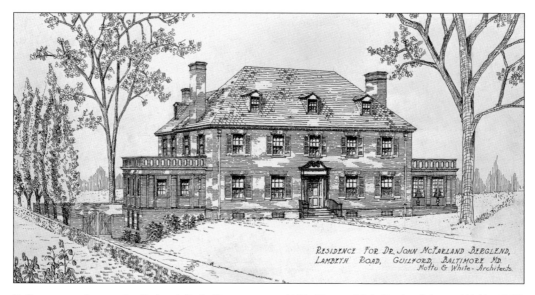

Following a plea to the Roland Park Company in 1913, Howard McCauley Mottu (1868–1953) and Henry Schroeder Taylor White (1879–1946) received several Guilford commissions. This brick home on Lambeth Road was designed in 1927 for Dr. John McFarland Bergland, a leading obstetrician and early advocate for planned parenting. Landscape architect Thomas Warren Sears (1880–1966) is responsible for the gate and walled garden. Compare the preliminary drawing (above) with the home as it looks today (below). (Above, Hughes Company Glass Negative Collection, the Photography Collections, University of Maryland, Baltimore County; below, Greg Pease Photography.)

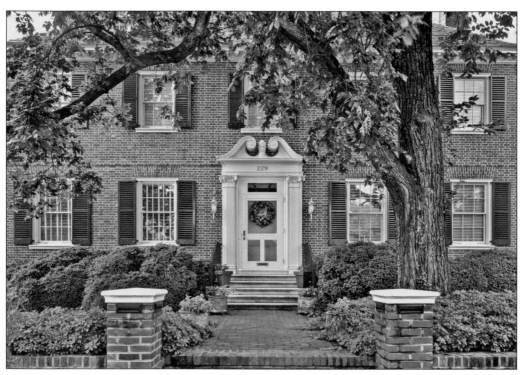

This Colonial Revival Wendover Road home is another Mottu and White project. The residence may have been built by 1916, but the garage was added later. Early owners included Herman Lohmeyer, a men's clothier whose clothing concern later merged with Payne and Merrill. These contemporary photographs show the home as it is today with its front-entrance columns, pediment, and two fanlights (right) and beautifully appointed, light-filled living room and east porch (below). (Right, Greg Pease Photography; below, Anne Gummerson Photography.)

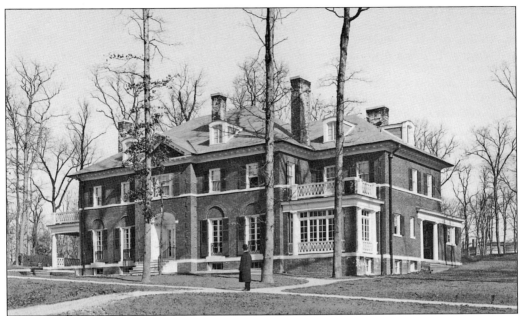

Benjamin Buck Owens (1841–1918) and Spencer Edward Sisco Sr. (1874–1951) designed this grand brick home for Eben B. Hunting in 1914. Hunting was a lumberman who built a large real estate portfolio. The first floor has French doors throughout, a wide center hall with Ionic columns, and a living room (below) with beamed ceilings and library shelving. (Above, records of the Roland Park Company, MS 504, Box 293, Special Collections, Sheridan Libraries, Johns Hopkins University; below, records of the Roland Park Company, MS 504, Box 295, Special Collections, Sheridan Libraries, Johns Hopkins University.)

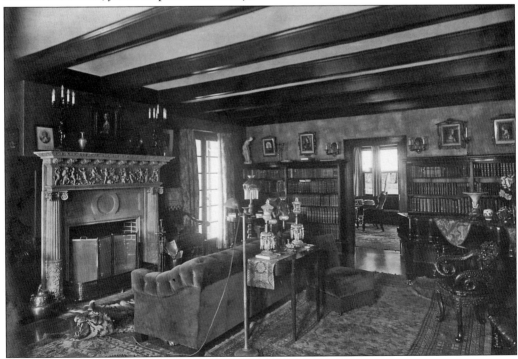

This brick Wendover Road home, with a steeply pitched slate roof, tall chimneys, and bay windows, was designed by Thomas Bond Owings (1885–1961) for lawyer James McEvoy in 1914. McEvoy was a member of the Baltimore City Board of Police Commissioners. His term overlapped with that of neighbor Daniel C. Ammidon (see page 42). The new owner, Alexander Edward Duncan, hired Laurence Hall Fowler to design a breakfast porch in 1920. Duncan was born in Kentucky but relocated to Baltimore, where he founded the Credit Commercial Company (now part of Citigroup) in 1912. Six years later, Duncan commissioned Fowler to design Cedarwood, a home on North Charles Street just outside of Guilford. (Both, records of the Roland Park Company, MS 504, Box 295, Special Collections, Sheridan Libraries, Johns Hopkins University.)

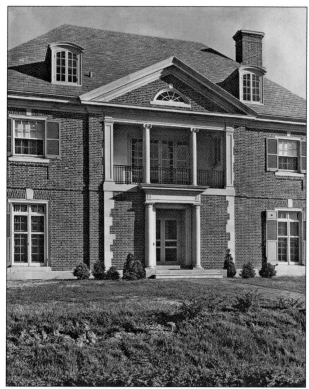

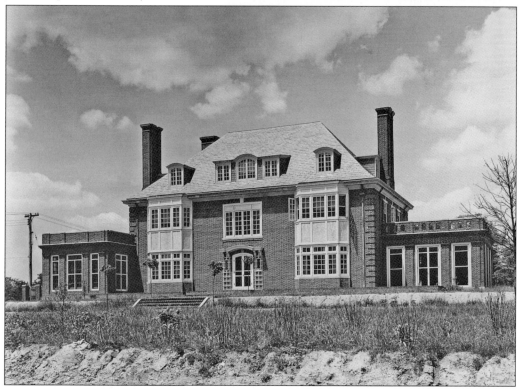

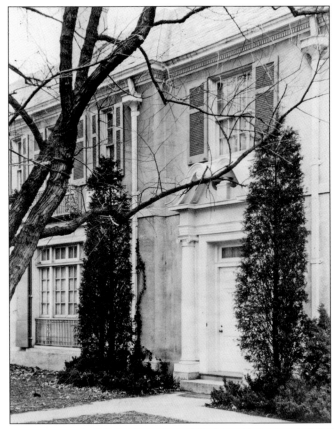

John Harleston Parker (1873–1930), Douglas Hamilton Thomas Jr. (1872–1915), and Arthur Wallace Rice (1869–1938) designed important buildings in both Boston and Baltimore. Many of the firm's projects are individually listed in the National Register of Historic Places, including the Baltimore Gas and Electric Building (1916). The firm designed this early stucco Greenway home. (Both, records of the Roland Park Company, MS 504, Box 286, Special Collections, Sheridan Libraries, Johns Hopkins University.)

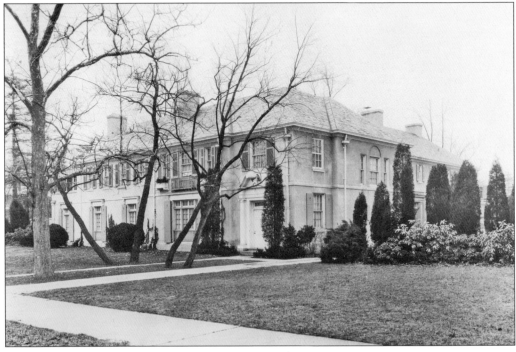

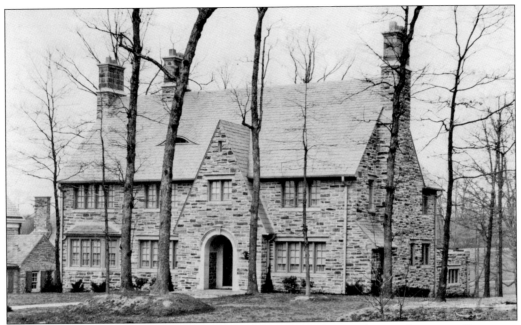

Parker, Thomas & Rice was also responsible for the variegated-stone home on Greenway commissioned by attorney Edward L. Ward. The April 1926 *Roland Park Company's Magazine* describes the home as an "example of English architecture, the inspiration of which was the type of house found in Cotswold." (Records of the Roland Park Company, MS 504, Box 286, Special Collections, Sheridan Libraries, Johns Hopkins University.)

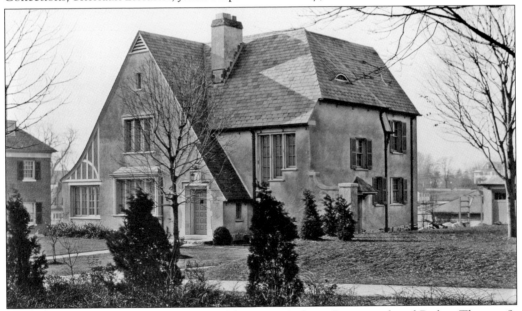

In 1924, John L. Whitehurst, president of the Burt Machine Company, hired Parker, Thomas & Rice to design a home for his St. Paul Street lot. The home was listed in 1936 "at a surprisingly reasonable figure" (*Gardens, Houses and People*, August 1936), and the Whitehurst family moved to the General Waters home on Greenway (see page 93). (Records of the Roland Park Company, MS 504, Box 286, Special Collections, Sheridan Libraries, Johns Hopkins University.)

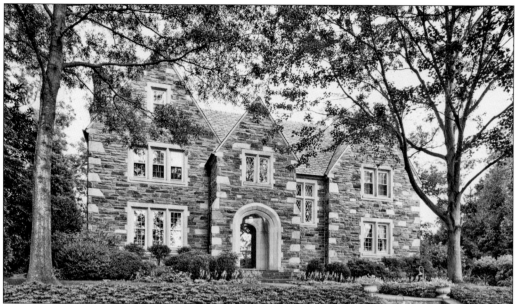

Theodore Wells Pietsch (1868–1930) is known for the Broadway Recreation Pier (1914) and SS. Philip and James Catholic Church (1929). This stone Highfield Road residence was the home of John Edwin Greiner (1859–1942), one of the country's most highly regarded bridge engineers. Some sources attribute this home to Pietsch in association with Greiner, but it is difficult to know how much Greiner contributed. Designed in 1929 and built by the Davis Construction Company, the home features detailed millwork, sandstone fireplace surrounds, and a "living and dining terrace overlooking an attractive garden" (*Gardens, Houses and People*, October 1941). (Both, Greg Pease Photography.)

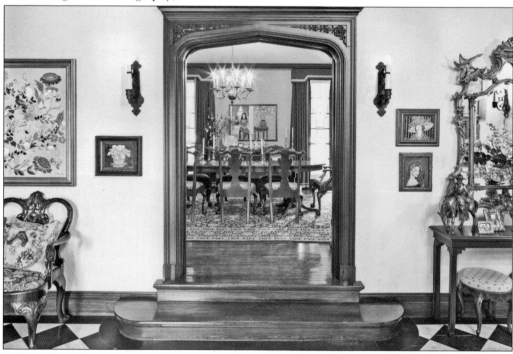

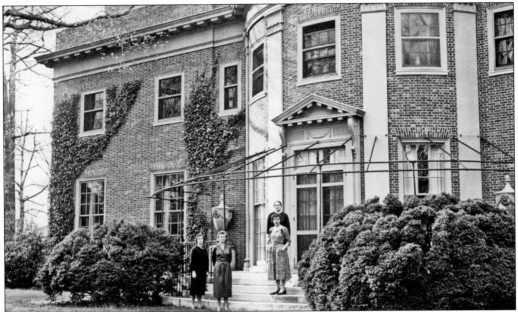

Classical Revival Charlcote House was designed by John Russell Pope (1873–1937) for lawyer James Swan Frick and his wife, the former Elise Winchester Dana. Frick chose the site for his new home with care. The Olmsteds proposed peonies, oriental poppies, starwort, iris, forget-me-nots, and Japanese windflower for the grounds. The Cowan Building Company completed the home by 1916, but Elise Frick died in December of that year. Pallbearers included the architect J.B. Noel Wyatt (see page 96). Charlcote House was designed just as Pope's career was on an upward arc and coincided with a shift from residential projects to the monumental architecture for which he is known. Charlcote House is individually listed in the National Register of Historic Places. (Above, photograph by Frank Gardina, courtesy of the *Baltimore Sun*; below, photograph by a *Baltimore Sun* staff photographer, courtesy of the *Baltimore Sun*.)

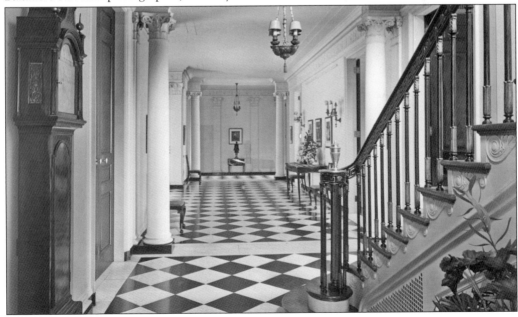

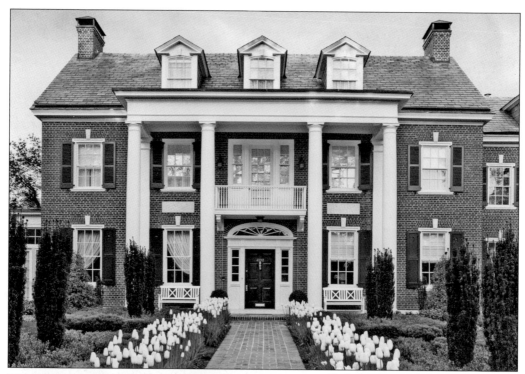

Philadelphia architect Louis Harold Rush (1880–1942) designed this c. 1916 Classical Revival home for Julian Stuart Carter of the real estate firm Carter and Steffey, and his wife, the former Alice Bowdoin Rush, the architect's sister. The second owner, Frederick Grayson Boyce Jr., a member of a prominent banking family, hired Wilson Levering Smith (1873–1931) and Howard May (1879–1941) to expand the home. Boyce's daughter Sophie Meredith stands in the hall (left). Oceanographer and mathematician Dr. John Edward Johnston Jr., who had been raised in nearby Charlcote House (see page 83), also resided here. Johnston was widely known for his exotic-bird menagerie; the home has been the Bird Man's House since his occupancy. (Above, Greg Pease Photography; left, photograph by Bachrach, courtesy of the *Baltimore Sun*.)

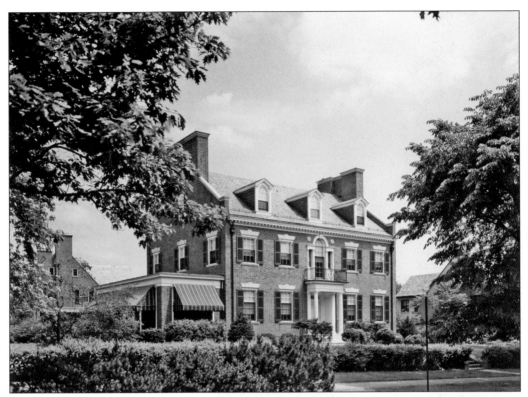

Howard Sill (1867–1927) was active in the Roland Park Company's district. His residential commissions include Guilford's Sherwood Mansion (see page 118). In 1924, Sill designed this Greenway home for Francis A. White. White's profession was given as real estate, but he was also sometimes simply listed as a capitalist. The home features a Palladian window and rosettes just above the front entrance. (Above, records of the Roland Park Company, MS 504, Box 286, Special Collections, Sheridan Libraries, Johns Hopkins University; right, *Gardens, Houses and People* 1952 © Enoch Pratt Free Library, Maryland's State Resource Center. All Rights Reserved. Used with permission. Unauthorized reproduction or use prohibited.)

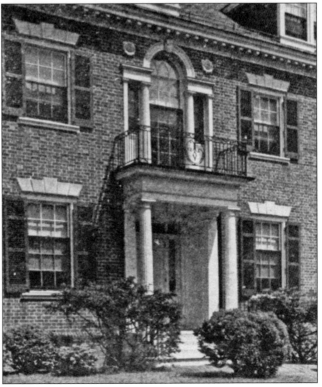

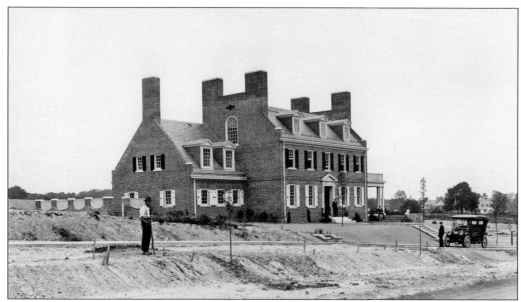

The following year, Sill designed a St. Paul Street home for Richard H. Lynch, a US Federal and Guarantee Company executive. The project may have originally been planned for a lot at Greenway and Wendover Road. The home was built with a detached garage set back from the home, brick garden wall, terrace, and well-developed gardens, including a rose garden. The photograph above shows the home complete and men landscaping along St. Paul Street. The photograph below offers a view of the formal rear garden. (Above, records of the Roland Park Company, MS 504, Box 293, Special Collections, Sheridan Libraries, Johns Hopkins University; below, records of the Roland Park Company, MS 504, Box 295, Special Collections, Sheridan Libraries, Johns Hopkins University.)

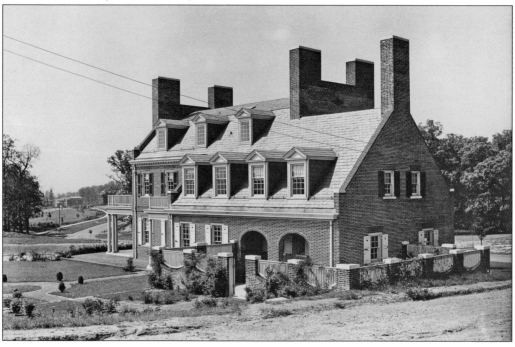

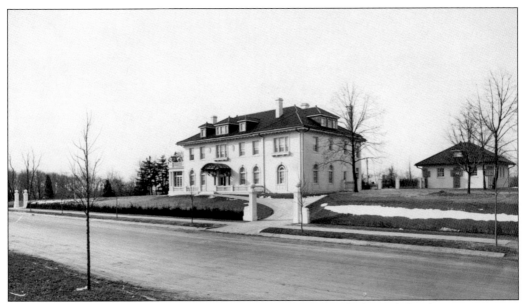

One of the more unusual homes in Guilford is this stucco and tile-roofed Italian Renaissance Revival home by Otto Ludwig G. Simonson (1862–1922). The home was constructed on three lots for Frank Henry Gunther of the George Gunther Jr. Brewing Company. The residence is shown here shortly after completion late 1915 or early 1916. At the same time, Simonson designed a Mission Revival residence for George Gunther Jr. at North Charles Street and Bellona Avenue. Simonson is remembered for the brick Romanesque Revival Gunther Brewing Company brewhouse (1904 preliminary plans), designed in association with partner Theodore Wells Pietsch (see page 82), and the Maryland Casualty Company Home Office Buildings (1920) known as the Rotunda. (Both, the West Construction Company Album, courtesy of L. Gladstone.)

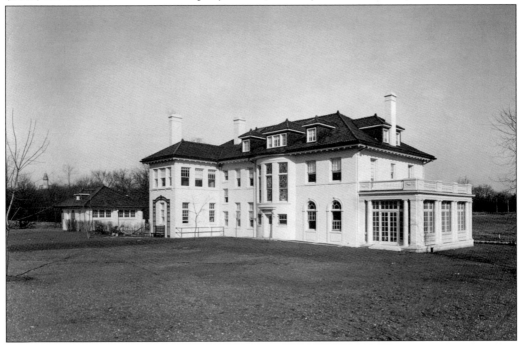

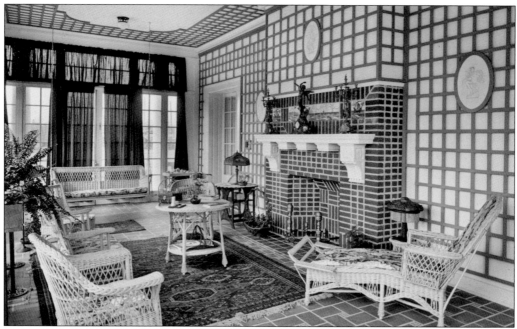

The Gunther home was a lavish residential project constructed to commercial standards. Interior walls were more than 10 inches deep. Large decorative glass windows grace the landing of the main stair from the first to the second floors, and original Tiffany Studios lighting fixtures are found throughout. The enclosed porch (above) has a brick fireplace embellished with handmade Arts and Crafts tiles. The dining room (below) has splayed red-oak paneling. In 1929, Dr. George Avery Bunting and his wife, the former Nellie Bowen, purchased the home. Bunting founded the Noxzema Chemical Company, renamed the Noxell Company and acquired by Procter & Gamble in 1989. (Both, the West Construction Company Album, courtesy of L. Gladstone.)

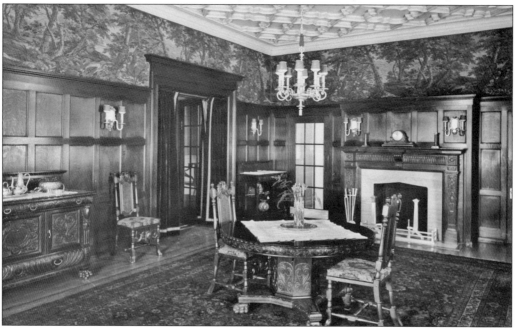

Joseph Evans Sperry (1854–1930) is known for the Equitable Building (1891), the Eutaw Place Temple of Congregation Oheb Shalom (1892), the Brewers Exchange (1895), and the Emerson Bromo-Seltzer Tower (1911). Sperry designed this Bishops Road home for Henry Gerhard Hilken, a senior officer of A. Schumacher and Company and a shipping agent for the North German Lloyd Steamship Company. Hilken's offices were in Hansa Haus (1912), a newly built half-timbered German Renaissance Revival building designed by Parker, Thomas & Rice (see page 80) that also housed the consulates of Germany and Sweden. Hilken served as the German consul. His son Paul G.L. Hilken, although American-born, was a German agent during World War I. (Both, records of the Roland Park Company, MS 504, Box 295, Special Collections, Sheridan Libraries, Johns Hopkins University.)

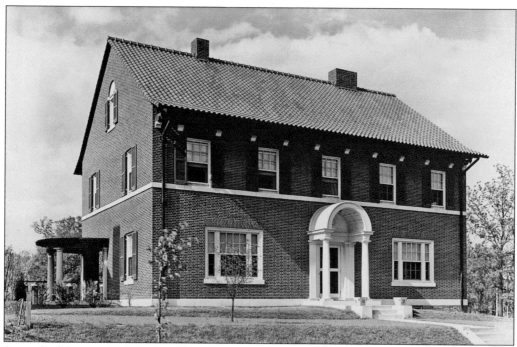

Sperry built his own Bishops Road home next to the house he had designed for Henry Hilken. Both homes were redbrick with tile roofs, but Sperry designed his residence with a columned, arched front entrance and a columned porch and loggia on the garden side. Clover Hill (below) sits just to the right on the grounds of the planned procathedral. (Both, records of the Roland Park Company, MS 504, Box 295, Special Collections, Sheridan Libraries, Johns Hopkins University.)

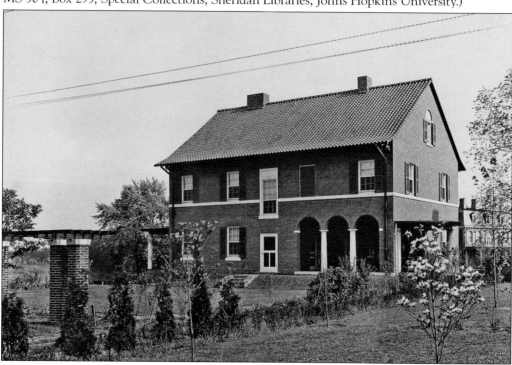

Bayard Turnbull (1879–1954) designed several important homes in the Roland Park Company's district and on Gibson Island, but he specialized in renovations to historic homes. He supervised the relocation and reassembly of the 18th-century Stemmer's Run House and worked on the old Carroll property, Sweet Air. He designed this Chancery Road home in 1927 for his sister Grace Hill Turnbull, an artist whose works include *Naiad*, installed at Baltimore City's Mt. Vernon Place, *Triad*, at the Baltimore Museum of Art, and *Python*, at the Metropolitan Museum of Art. Influenced by her trips to Spain and to the West Indies, the artist commissioned this buff-colored stucco and timbered Mission Revival home with a walled garden. (Both, photograph by Leopold, records of the Roland Park Company, MS 504, Box 286, Special Collections, Sheridan Libraries, Johns Hopkins University.)

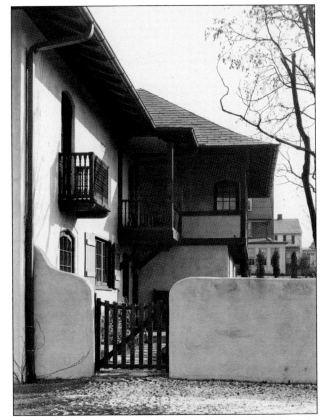

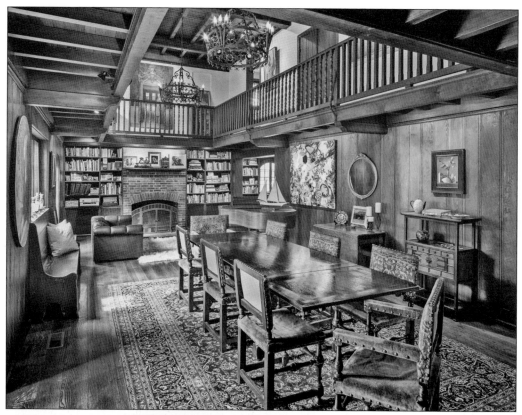

The Grace Hill Turnbull House, as it is now known, is built around a great room, which served as an art gallery (above). Turnbull carved much of the furniture herself. She also carved several tall wooden posts into sculptures, which were then installed at the corners of her home. Shown here is *Christ Touching a Dead Soul to Life* (left). The residence has a separate building that served as both garage and studio—a monastic folly with a pulpit, stained-glass window, and bell tower. The home is a designated Baltimore City Landmark. (Above, Greg Pease Photography; left, *Gardens, Houses and People* 1943 © Enoch Pratt Free Library, Maryland's State Resource Center. All Rights Reserved. Used with permission. Unauthorized reproduction or use prohibited.)

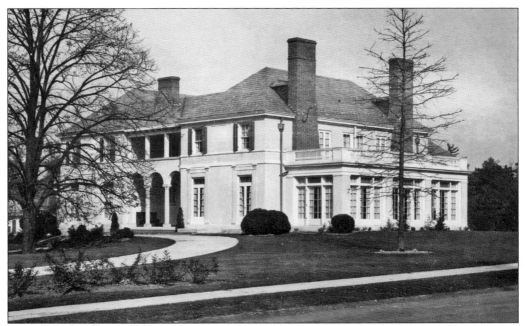

Bayard Turnbull designed an Italian Renaissance Revival home on Greenway for Gen. Francis Edward Waters. The house is shown above as it looked in 1923. Waters owed his wealth to the lumber business started by his father. He served as director of the Maryland Penitentiary and was a commissioner of the State of Maryland at the Louisiana Purchase Exposition in St. Louis, Missouri. General Waters never served in the military; Gov. Elihu Emory Jackson made Waters a colonel, and Gov. John Walter Smith elevated him to brigadier general. The photograph below is a contemporary view taken from the front entrance. (Above, photograph by a *Baltimore Sun* staff photographer, courtesy of the *Baltimore Sun*; below, Greg Pease Photography.)

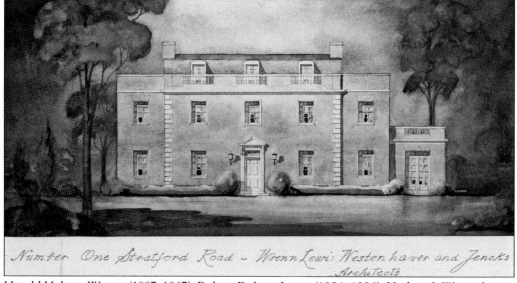

Number One Stratford Road – Wrenn Lewis, Westenhaver and Jencks Architects

Harold Holmes Wrenn (1887–1967), Robert Erskine Lewis (1904–1996), Herbert J. Westenhaver, and Francis Haynes Jencks (1902–1991) began as Lewis and Westenhaver. Westenhaver left the firm in 1929, and the practice continued as Wrenn, Lewis & Jencks through 1978. Wrenn was an artist and left watercolors documenting the firm's work. This Stratford Road exhibition home, designed in 1931 for builders Gunn, Williamson & Guy, featured a pine-paneled library, basement "club quarters with an adjoining room convenient for mixing and serving lemonade, grape juice, ginger pop and so on" (*Gardens, Houses and People*, April 1931), and a walled garden. (Above, Wrenn, Lewis and Jencks Collection, Baltimore Architectural Foundation; below, photograph by Leopold, records of the Roland Park Company, MS 504, Box 286, Special Collections, Sheridan Libraries, Johns Hopkins University.)

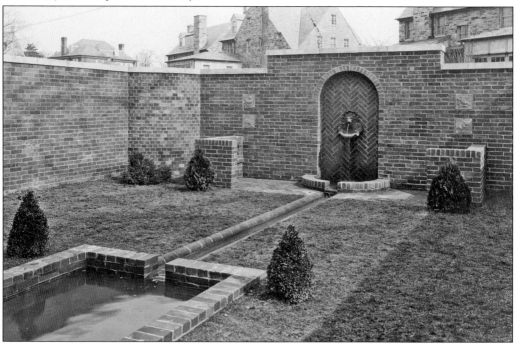

Wrenn, Lewis, Westenhaver & Jencks designed a white-painted brick home for Dr. Alan Churchill Woods Sr. on Millbrook Road (above). Dr. Woods was an ophthalmologist who served as chairman of the medical board of Johns Hopkins Hospital and director of the Wilmer Ophthalmological Institute. The company approved plans for this home in May 1926 following minor changes to the preliminary design. (Wrenn, Lewis and Jencks Collection, Baltimore Architectural Foundation.)

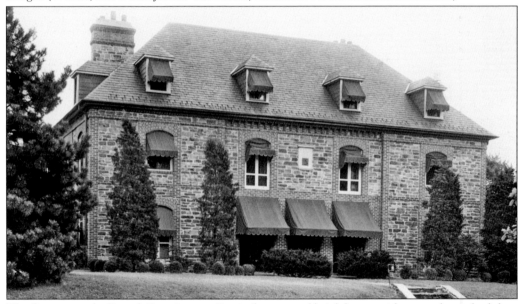

The firm created a French Renaissance Revival stone and brick home with a steeply pitched slate roof for Bertram Constable and Edward J. McGraw, which was offered for sale in March 1930. Early occupants included John O. Mitchell, who ran a successful funeral home still in business today. Mitchell had tried to purchase a home in the district previously, but his application was placed in the dreaded "Excluded" file; the company did not sell to funeral-home directors. (Records of the Roland Park Company, MS 504, Box 286, Special Collections, Sheridan Libraries, Johns Hopkins University.)

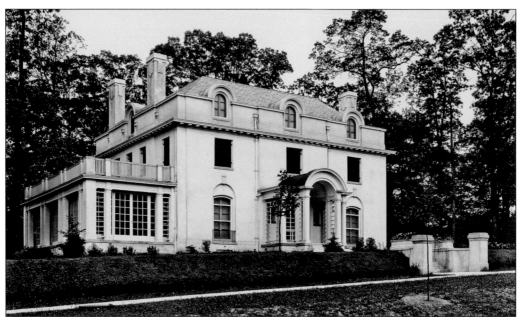

James Bosley Noel Wyatt (1847–1926) and William Greanor Nolting (1866–1940) are remembered for the Roland Park Shopping Center (1895), the original Baltimore Country Club (1898), the Baltimore Courthouse (1899), and Fifth Regiment Armory (1901, 1933). They designed this stucco home on St. Paul Street in 1913 for Alexander Edward Duncan, who later moved to a home on Wendover Road (see page 79). Subsequent owners included R. Walter Graham, a Baltimore City comptroller. The residence is shown after completion (above) and under construction (below). (Above, records of the Roland Park Company, MS 504, Box 295, Special Collections, Sheridan Libraries, Johns Hopkins University; below, records of the Roland Park Company, MS 504, Box 293, Special Collections, Sheridan Libraries, Johns Hopkins University.)

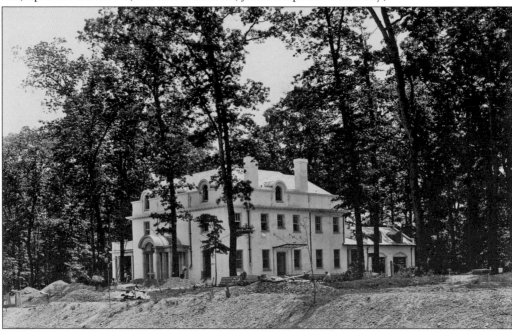

Six

THE "MONUMENTALS"

Plans for Guilford assumed that educational and ecclesiastical building and public parking on a grand scale would occur on adjacent parcels. Anticipated development included an Episcopalian procathedral complex at Guilford's southern entrance, Johns Hopkins University's new Homewood campus, Wyman Park, and the Baltimore Museum of Art.

Other space-constrained institutions in the city center vied for suburban locations in or adjacent to Guilford. Loyola College (now Loyola University) and Second Presbyterian Church considered several Guilford sites before settling on their present locations. The First Church of Christ, Scientist (1913) was erected on University Parkway, followed by the New Orthodox Friends Meeting House (1921), now Homewood Friends Meeting House, University Baptist Church (1927), the Alpheus W. Wilson Memorial Methodist Episcopal Church South (1927), First English Lutheran Church (1928), Saints Philip and James Catholic Church (1929), and Scottish Rite Temple of Freemasonry (1932) along North Charles Street.

Unanticipated conflicts arose among these relocating "monumentals." Procathedral trustees in particular defended their choice site aggressively. They prevented an Episcopal congregation from building another church nearby and fought the Greenway Apartment Company's attempt to build an apartment house, resulting in a legal battle that went to the US Supreme Court. Pleasing everyone proved impossible, and the building continued.

Elizabeth A. Parker wrote to Roland Park Company president Edward H. Bouton:

> The Hopkins Plaza property is reeking with apartment houses now. Both sides of 34th Street, from Charles to St. Paul, have giant structures, The Greenway on the north side about completed, and The Cambridge on the south just being started, the latter being Mr. Palmer's plan, and he assures me that it will look like a 'gentleman' alongside the Greenway. (Letter to Bouton, April 12, 1920, Olmsted Associates Records at the Library of Congress.)

Residents kept apartment buildings firmly out of Guilford, using a variety of tactics, but at the western perimeter, the community bemoaned a "Chinese wall" of apartment houses. The Episcopal cathedral, which had purchased the Bauernschmidt house (see page 20) at University Parkway and Saint Paul Street, eventually sold it. The new owners tore it down and built another apartment building directly across from the cathedral.

Various sites were considered for Loyola College, now Loyola University. Shown above is the preliminary study for the new suburban campus when the school hoped to build within Guilford. These unexecuted plans, by Boston architects Charles Donagh Maginnis (1867–1955) and Timothy Francis Walsh (1868–1934), include a complex of buildings. The sign in the photograph below marking the "Future Site of Loyola College" was located at St. Paul Street south of University Parkway, just south of Guilford. The final site, purchased from the Garrett family, fronts onto North Charles Street above Cold Spring Lane, north of Guilford. (Above, records of the Roland Park Company, MS 504, Box 292, Special Collections, Sheridan Libraries, Johns Hopkins University; below, records of the Roland Park Company, MS 504, Box 293, Special Collections, Sheridan Libraries, Johns Hopkins University.)

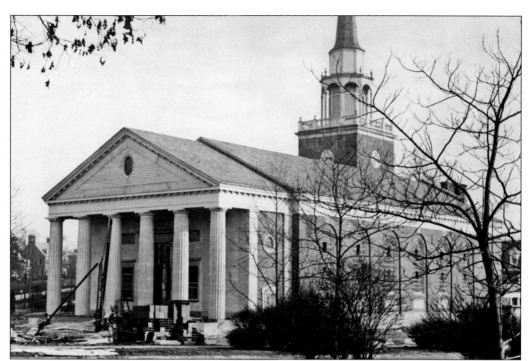

The company also weighed a casino and business center and a clubhouse for the benefit of residents, but only two buildings were constructed that were not single-family homes. The first is the Bedford Square Waiting Station, designed by Edward L. Palmer Jr. (see page 33), where the streetcar line ended. The second building is Second Presbyterian Church, designed by Palmer and Lamdin (see page 33). The church was constructed in phases, with the church house and tower started in 1924, and sanctuary and manse in 1929. The photograph above shows the Classical Revival portico under construction. The photograph at right shows the church from St. Paul Street and Stratford Road. (Both, photograph by a *Baltimore Sun* staff photographer, courtesy of the *Baltimore Sun*.)

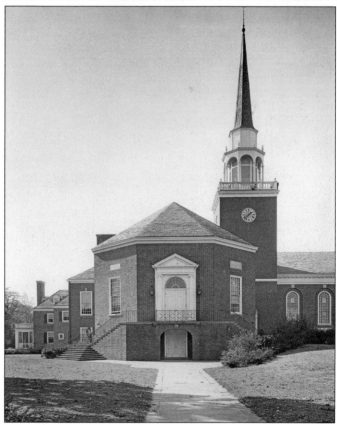

The Episcopal procathedral was the first building planned "at Guilford" but almost the last to be constructed. The site is not part of the Guilford development's plat; it is adjacent to the southern entrance to Guilford. Fundraising proved problematic, and church representatives argued over design. They did agree that "every portion of its vast fabric must be absolutely the best of its kind, in design, artistry and workmanship" (*Architectural Record*, January 1913). They hired first Henry Vaughan (1845–1917), supervising architect for the Washington National Cathedral, then Edward Hughes Glidden Sr. (see page 72), who designed the Norman-style Undercroft (left). Bertram Grosvenor Goodhue (1869–1924) of Cram, Goodhue & Ferguson, was eventually commissioned to design the entire complex. A concept drawing by Goodhue is shown below. (Both, archives of the Episcopal Diocese of Maryland.)

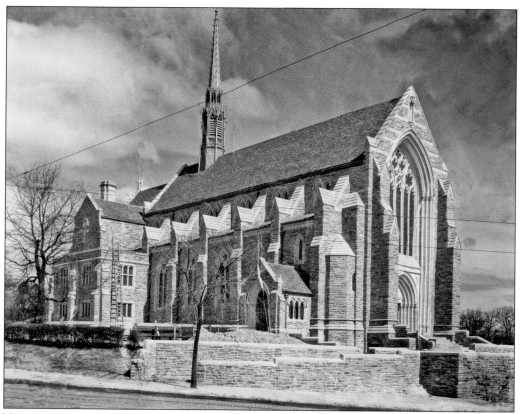

Not everyone favored Goodhue's approach. One committee member expressed "a rooted distaste for the work which they have executed, and a rooted lack of confidence . . . in their ability, to design in what I consider to be good Gothic," and Goodhue's design was described as having "all the irritating lack of sharpness of outline of the Melting Mould of Ice Cream School at its worst or best" (Archives of the Episcopal Diocese of Maryland). Goodhue returned the compliment with blistering rebuttals. He died unexpectedly in 1924, and the trustees never were able to realize funds for the cathedral complex. They hired Philip Hubert Frohman (1887–1972) of Frohman, Robb & Little to design the more modest English Gothic Cathedral of the Incarnation completed in 1932. (Above, BGE Collection at the Baltimore Museum of Industry; below, photograph by a *Baltimore Sun* staff photographer, courtesy of the *Baltimore Sun*.)

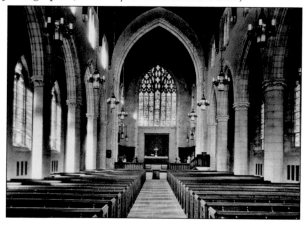

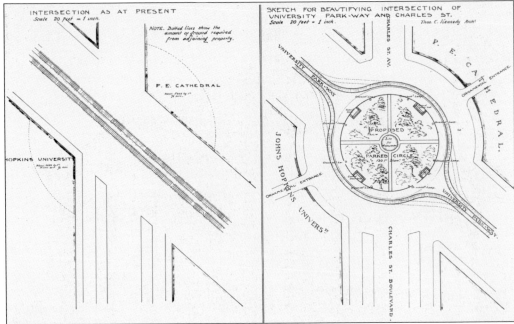

While the church trustees struggled to build their procathedral, the Roland Park Company had its own challenges developing the intersection between the procathedral and the Johns Hopkins University campus. Above, the intersection of Charles Street and University Parkway is shown as it was (left) and as proposed by the company and the Olmsteds (right). The proposed "parked circle" stalled. A triangular park just north of the intersection was created, and the Confederate Women's Monument designed by Joseph Maxwell Miller (1877–1933) was added soon after, pictured below. This public park is named Bishops Square Park and occupies the site of the old tollgate and toll-keeper's house. (Above, National Park Service, Frederick Law Olmsted National Historic Site; below, Hughes Company Glass Negative Collection, the Photography Collections, University of Maryland, Baltimore County.)

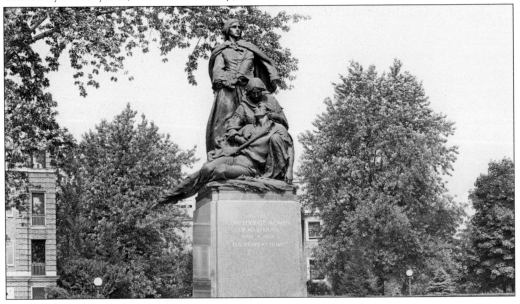

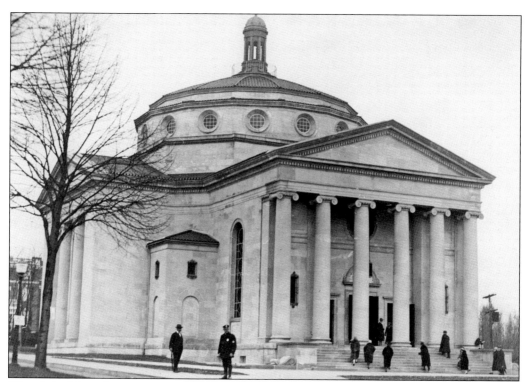

Church buildings began to rise adjacent to Guilford, particularly along North Charles Street. John Russell Pope (see page 83) designed University Baptist Church, at North Charles Street and Greenway, across from Johns Hopkins University. The octagonal-domed church was constructed of Indiana limestone with a green tile roof. The original portion of the church was dedicated in 1927. (Photograph by a *Baltimore Sun* staff photographer, courtesy of the *Baltimore Sun*.)

The work of Alfred Cookman Leach (1874–1933), the Alpheus W. Wilson Memorial Methodist Episcopal Church South at North Charles Street and University Parkway was completed in 1927. Leach was named for Rev. Alfred Cookman, a 19th-century abolitionist Methodist minster. The building is now the Johns Hopkins University's Bunting-Meyerhoff Interfaith and Community Service Center. Leach designed a Guilford residence for William Frederick Schluderberg, whose company, Schluderberg-Kurdle (known as Esskay), was acquired by Smithfield Foods. (Photograph by Leopold, archives of the Episcopal Diocese of Maryland.)

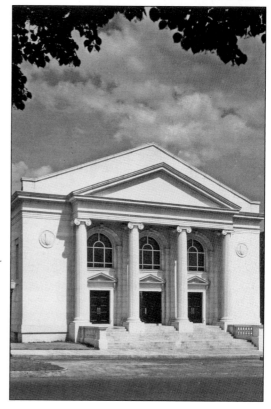

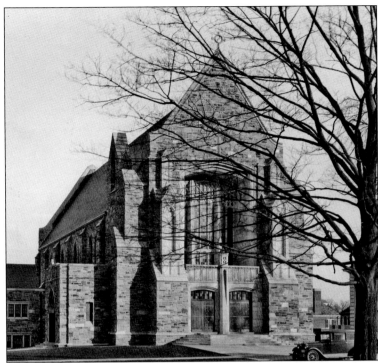

The First English Lutheran Church at North Charles and Thirty-ninth Streets was designed by Parker, Thomas & Rice (see page 80) and built by Thomas Hicks and Sons. Seymour and Sons did the stonework using Gwynns Falls and Butler stone. The site was purchased and consecrated in 1925, and the church was dedicated in 1928. (Records of the Roland Park Company, MS 504, Box 286, Special Collections, Sheridan Libraries, Johns Hopkins University.)

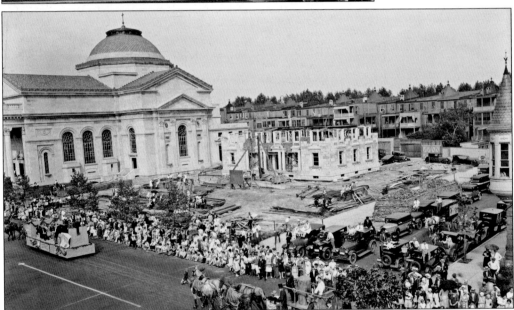

SS. Philip and James Catholic Church on North Charles Street between Twenty-eighth and Twenty-ninth Streets is the work of Theodore Wells Pietsch (see page 82). Completed in 1929, this church is one of his best-known commissions. Here, the tile-roofed Indiana limestone church is shown completed, but the rectory is still under construction. One of the floats in the Baltimore bicentennial celebration parade passing in front of the church carries a replica of *Tom Thumb*, one of the first American-built steam locomotives. (BGE Collection at the Baltimore Museum of Industry.)

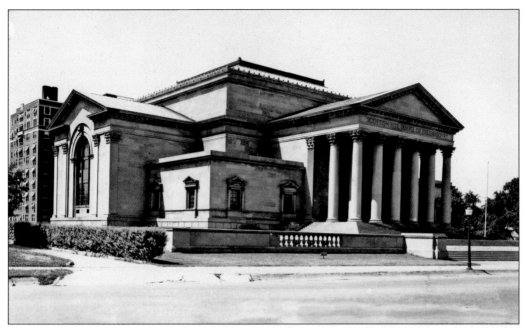

The Scottish Rite Temple of Freemasonry at North Charles and Thirty-ninth Streets is the work of Clyde Nelson Friz and Nelson Friz (see page 70). The land was purchased in 1925, and the Indiana limestone building was complete by 1932. The building earned its owners the Architectural Medal for 1931 for being the "most pleasing" building erected that year in Baltimore City. Consulting architect John Russell Pope (see page 83) is often credited (without basis) with the building's most notable feature—the columned barrel-vaulted front portico. The end of Prohibition in 1933 meant rooms for gambling and drinking were no longer required, so several large rooms remain unfinished. The building is now a designated Baltimore City Landmark. (Above, private collection; right, photograph by A. Aubrey Bodine, courtesy of the *Baltimore Sun*.)

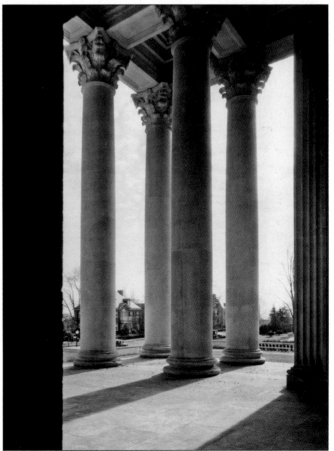

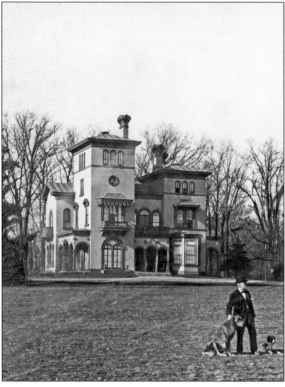

When the university took possession of its Homewood campus, buildings already located on the grounds included Homewood House (1804), built by Robert and William Edwards for Charles Carroll Jr., son of the Maryland signer of the Declaration of Independence (above far right), a stable with cupola (above center) called the Barn, the Coachman's House, later known as Owen House (above top), Homewood Villa (1853), built for William Wyman (left), and the stone gatehouse (1875). Homewood House was retained, and campus buildings were designed to harmonize with it. Today, Homewood House is a museum and National Historic Landmark. The Barn and the gatehouse remain, but the Homewood Villa and the Coachman's House were both demolished. (Above, BGE Collection at the Baltimore Museum of Industry; left, photograph by a *Baltimore Sun* staff photographer, courtesy of the *Baltimore Sun*.)

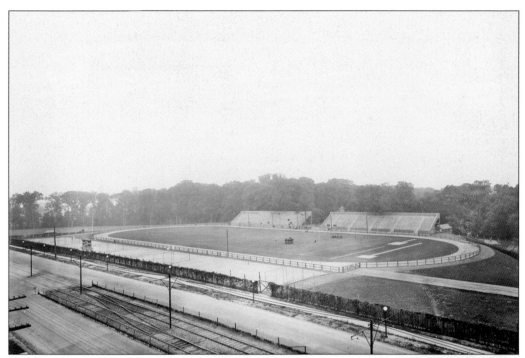

Plans to relocate Johns Hopkins University to a new suburban campus at North Charles Street and University Parkway proceeded slowly, despite the university's land hunger. Initial plans called for the campus to be oriented on University Parkway. The athletic field (above), greenhouses, and botanical garden (right) were completed first. Of the botanical garden, Lillian C. Canfield writes, "Stillness, interrupted only by the sweet cries of birds, pervades this park so sheltered from the city's traffic and yet so proximate to turmoil on every margin" (*Baltimore Sun*, May 6, 1928). (Above, Hughes Company Glass Negative Collection, the Photography Collections, University of Maryland, Baltimore County; right, photograph by a *Baltimore Sun* staff photographer, courtesy of the *Baltimore Sun*.)

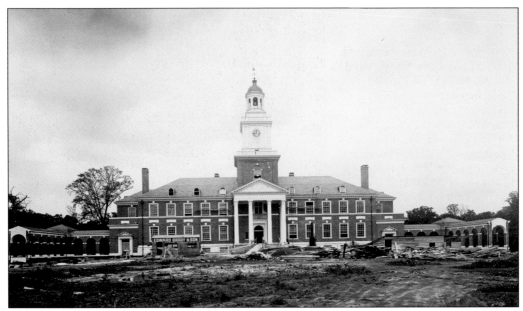

By the time the university started its building campaign in earnest, university officials had decided to orient the campus on North Charles Street. The campus, with the exception of the athletic field and greenhouses, follows this new plan. Originally known simply as "the academic building," Gilman Hall (pictured) was formally named in honor of the university's first president, Daniel Coit Gilman, upon completion in 1915. Douglas Hamilton Thomas Jr. of Thomas, Parker & Rice (see page 80) was a university alumnus (class of 1893) and is given credit for the design of Gilman Hall. The original design was submitted as part of a competition in 1904. (Above, Hughes Company Glass Negative Collection, the Photography Collections, University of Maryland, Baltimore County; below, photograph by Leopold, Ferdinand Hamburger Archives, Catalogue No. 00343, Gilman Hall, Sheridan Libraries, Johns Hopkins University.)

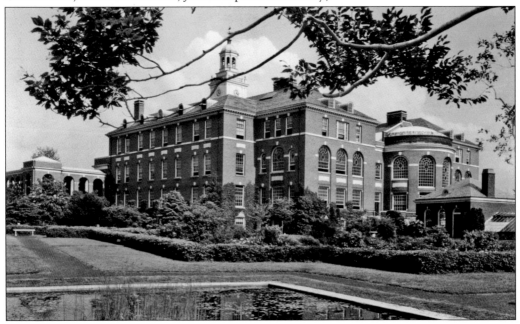

A portion of Homewood, owned by cousins William Wyman and William Keyser, heirs to dry-goods merchant Samuel Wyman, was set aside for a public park, named Wyman Park in honor of its benefactors. The Olmsteds *Report Upon the Development of Public Grounds for Greater Baltimore* (1904) lauds Wyman Park's "sylvan scenery." Letitia Stockett in *Baltimore: A Not Too Serious History* describes the terrain as "wild unspoiled country." The plans for Wyman Park were never fully realized, but today's park-goers do not seem to mind. Wyman Park offers paths for contemplative wooded strolls and pastoral expanses perfect for sunny-day baseball games. (Right, photograph by a *Baltimore Sun* staff photographer, courtesy of the *Baltimore Sun*; below, photograph by Jed Kirschbaum, courtesy of the *Baltimore Sun*.)

A final portion of Homewood was reserved for the Baltimore Museum of Art's new building, which opened in 1929. Established in 1914 as the Municipal Art Museum, the museum had occupied a series of temporary homes. The new museum was to be designed by Howard Sill (see page 85) in association with John Russell Pope (see page 83), but Sill became ill in 1926 and died the following year. The photograph above shows the museum as it looked shortly after it was built. Pope designed an addition a few years later to house Mary Frick Jacobs's collection of old master paintings. The photograph below shows men unloading art. (Above, private collection; below, photograph by a *Baltimore Sun* staff photographer, courtesy of the *Baltimore Sun*.)

The museum's collection continued to grow. The acquisition of the Cone Collection in 1949 marked a turning point. Considered the crown jewel of the museum's holdings, the collection of Claribel and Etta Cone included masterworks by Paul Cézanne, Paul Gauguin, Henri Matisse, Pablo Picasso, and Vincent van Gogh. The Cones lived intimately with their art. At right, the works of modern masters hanging in Etta's bathroom manage to both thrill and horrify. The photograph below documents another acquisition—two of the lions that once guarded the Abells' Guilford villa. These lions stood not at the gates but around the residence itself. They now sit outside the museum's Garden Room. (Right, photograph by Ralph Dohme, courtesy of the *Baltimore Sun*; below, photograph by Walter M. McCardell, courtesy of the *Baltimore Sun*.)

Along North Charles Street, the surviving country homes of the 1880s and 1890s gave way to apartment buildings. The Warrington (left) is a 12-story Georgian Revival luxury apartment building designed by Wyatt and Nolting (see page 96), completed by 1928. The Warrington replaced the Belle Lawn residence (see pages 19–20). The Northway (below) was designed by Palmer and Lamdin (see page 33) for the Greenway Apartment Company. The Northway was completed by 1932 after a protracted legal battle with Guilford residents, the Roland Park Company, and cathedral representatives who complained the apartment building would make the planned cathedral look like a "dog-kennel." (Left, photograph by Leopold, archives of the Episcopal Diocese of Maryland; below, BGE Collection at the Baltimore Museum of Industry.)

Seven

"Greensward and Garden Plots"

Guilford was the most lavishly parked of the Roland Park Company's developments. It was company president Edward H. Bouton who proposed large-scale park development at Guilford. The pastoral green spaces were to be a key selling point, and company advertisements from 1915 speak of "enjoying the spaciousness of the country, with its forest trees, greensward and garden plots" (*Roland Park Review* 1915).

Bouton suggested one major park to the north and another for the benefit of residents in the south. The final Olmsted plan for Guilford included three community parks—the Little Park, between Greenway and St. Paul Street, just north of the Gateway Houses; Sunken Park, bounded by Charles Street and Linkwood Road, designed to serve as an outdoor theatre; and Stratford Green, a rectangular parcel bounded by Greenway and Stratford Road. Stratford Green is now part of Sherwood Gardens, a well-known tulip-display garden.

Residence Park was planned but never built. The company expected to purchase the Howell estate, and this park would have been just to the south of that parcel. The Howell estate was bought by another developer and became Hadley Square. Instead, Guilford Gateways became Guilford's fourth community park. Occupying the triangle formed by Greenway and St. Paul Street north of University Parkway and south of the Gateway Houses, this parcel was to be the gateway into Guilford but remained undeveloped. In 1939, plans were unveiled for an apartment building at this site, but upset residents sued the company and won. Residents purchased the land and created the new park.

The parking of Guilford not only added to the beauty of the development; it also influenced how residents interacted. Unlike Roland Park, Guilford had no main street, no shopping center, and no community building or clubhouse. Community activities were consequently almost always held out of doors either in parks or private gardens. This tradition continues today.

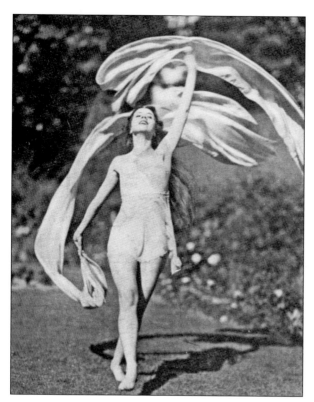

Estelle Owen Dennis performs *Spring Breeze* with the prizewinning North Charles Street garden of Clara Thomas as her stage in 1930. Born in Roland Park, Dennis danced with the Metropolitan Opera Corps de Ballet and the famed Denishawn Dancers. The Estelle Dennis/Peabody Dance Program for Boys is named in her honor. (*Gardens, Houses and People* 1930 © Enoch Pratt Free Library, Maryland's State Resource Center. All Rights Reserved. Used with permission. Unauthorized reproduction or use prohibited.)

This arrangement of mock orange "Virginal," *Philadelphus virginalis*, by Juniper Road resident Maria Briscoe Croker, won first prize at the Little Garden Club's first summer flower show in 1933. Croker served as Maryland's first poet laureate (1959–1962), and her poem "Bretton Place" expresses her love for this section of Guilford. (*Gardens, Houses and People* 1933 © Enoch Pratt Free Library, Maryland's State Resource Center. All Rights Reserved. Used with permission. Unauthorized reproduction or use prohibited.)

The Suffolk Road garden of Ella Nalle is pictured here (above) as it looked in 1928, the year her garden won the district garden contest sweepstake. Frederick Haas stands in his Greenway garden (right) holding his prized Wrexham delphinium. Haas's garden won first prize for Guilford in the 1928 district garden contest and the district garden contest sweepstakes in 1929. (Above, photograph by Willard R. Culver, the *Roland Park Company's Magazine* 1928 © Enoch Pratt Free Library, Maryland's State Resource Center. All Rights Reserved. Used with permission. Unauthorized reproduction or use prohibited; right, the *Roland Park Company's Magazine* 1929 © Enoch Pratt Free Library, Maryland's State Resource Center. All Rights Reserved. Used with permission. Unauthorized reproduction or use prohibited.)

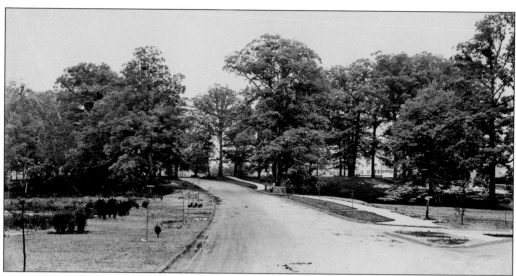

The Little Park sits just north of Guilford's Gateway Houses. The area that became the park is shown here (above left). The Olmsted plan included a path, planted islands, and a drinking fountain, but the park today, with its grassy swells and mature trees, has none of these. (Above, records of the Roland Park Company, MS 504, Box 293, Special Collections, Sheridan Libraries, Johns Hopkins University; below, National Park Service, Frederick Law Olmsted National Historic Site.)

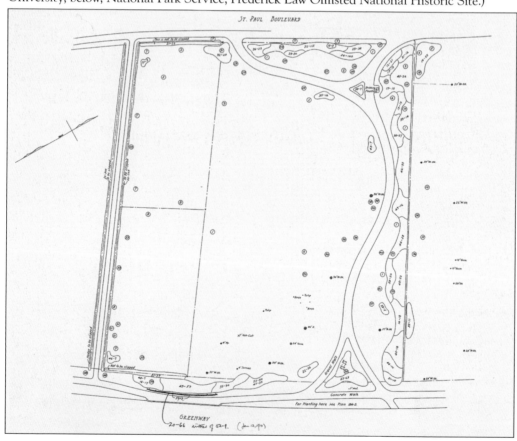

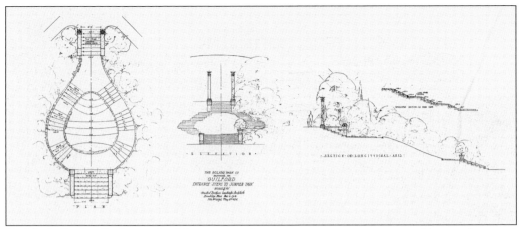

Guilford's Sunken Park was a highly engineered project requiring excavation and layers of material to achieve the desired effect. The entrance consists of freestanding columns leading to a split stair planted in the center and a walkway encircling the bowl-like park. The Olmsted plan is shown above. This photograph from 1929 is a rare early view of the park. (Above, National Park Service, Frederick Law Olmsted National Historic Site; below, the *Roland Park Company's Magazine* 1929 © Enoch Pratt Free Library, Maryland's State Resource Center. All Rights Reserved. Used with permission. Unauthorized reproduction or use prohibited.)

Stratford Green was to be an English-style green at Greenway and Stratford Road. The Olmsteds' plan shows curving walkways and a small walled pond and provided for the planting of many new trees, shrubs, and perennials. The plan preserved several old estate trees, some of which remain today. Stratford Green is pictured here (above) shortly after being planted. Approximately 10 years later, John Walter Sherwood and his wife, the former Mary Franklin Jones, purchased land adjacent to Stratford Green and constructed a large Georgian Revival home (below), known as the Sherwood Mansion. Howard Sill (see page 85) designed the home, which was patterned on Westover, a colonial home in Charles City, Virginia. (Above, records of the Roland Park Company, MS 504, Box 293, Special Collections, Sheridan Libraries, Johns Hopkins University; below, photograph by George H. Cook, courtesy of the *Baltimore Sun*.)

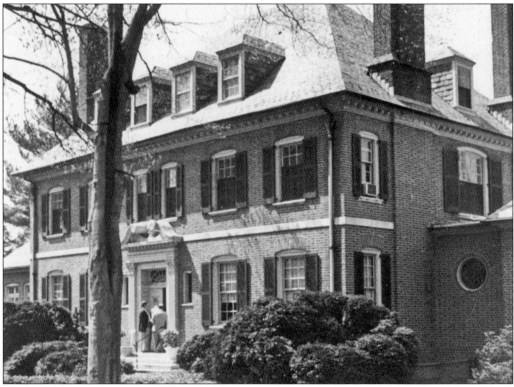

In 1926, Sherwood turned his attention to the grounds. He was a gifted amateur landscape designer and, due to his petroleum distribution business, particularly well funded. He employed a small army to tend his gardens, which eventually spread from his own property into Stratford Green. The grounds were planted for maximum springtime effect with ornamental cherry trees, dogwoods, lilacs, imported azaleas, and specimen evergreens serving as the backdrop to beds of bulbs and pansies. Sherwood started planting Dutch bulbs, first in small quantities but eventually by the thousands. Sherwood Gardens became a springtime destination. Visitors were permitted to stroll the grounds freely as shown in this photograph from 1948 (below), the same year the violet-blue Boris Van Amstel tulip made its American debut in Sherwood Gardens. (Right, photograph by a *Baltimore Sun* staff photographer, courtesy of the *Baltimore Sun*; below, photograph by Frank A. Miller, courtesy of the *Baltimore Sun*.)

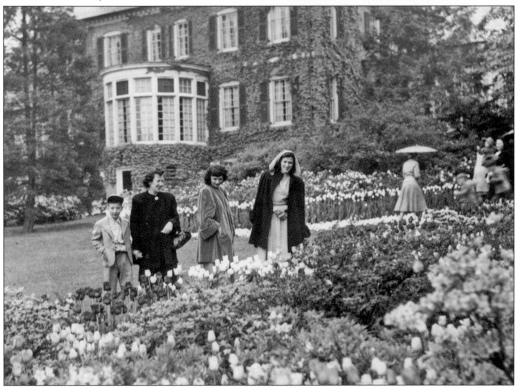

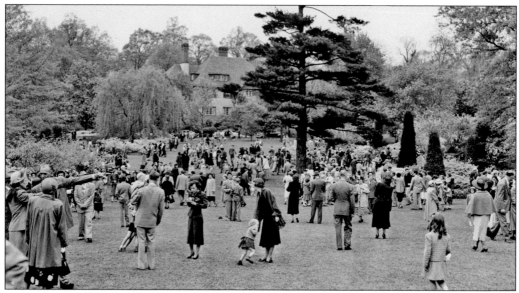

During the height of tulip season, Sherwood Gardens was filled with visitors. The photograph above, from 1950, shows a typical spring day in the gardens. Sherwood Gardens is featured in *National Geographic* magazine (April 1941, May 1956) and in books such as *Great Gardens of America* (Coward-McCann, 1969). Composer Franz Carl Bornschein's *The Earth Sings*, inspired by Sherwood Gardens, was performed by the Baltimore Symphony Orchestra. The premier performance was recorded by the Office of War Information and played for troops during World War II. The photograph below shows Sherwood garbed in dark suit and white hat walking with a cane through his gardens in 1959. (Above, photograph by Joshua S. Cosden, courtesy of the *Baltimore Sun*; below, photograph by Ralph Robinson, courtesy of the *Baltimore Sun*.)

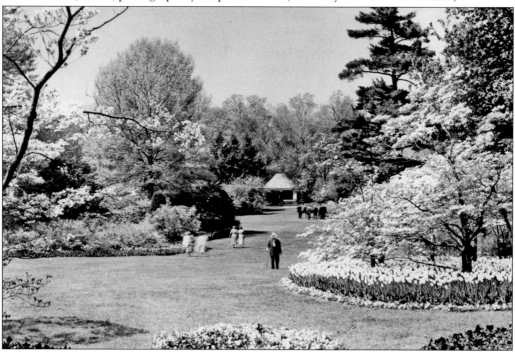

Trips to Sherwood Gardens were a rite of passage for area schoolchildren. Young children from Roland Park Country School visit the tulips (above). In 1955, school children from Montebello School enjoyed an outdoor art class (below). The gardens have no play equipment or sandbox—none are needed. Children manage to have a great deal of fun simply roaming the grounds. Hide-and-seek is a perennial favorite. (Above, Roland Park Country School; below, photograph by Walter McCardell, courtesy of the *Baltimore Sun*.)

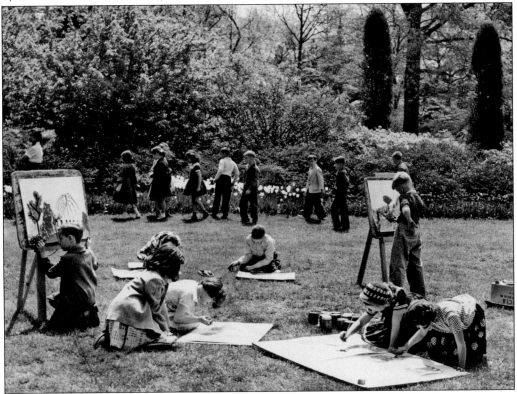

In 1965, John W. Sherwood passed away. His will left funds to plant the gardens one last time. The city mourned the loss of its "riotous ebullience of bloom" (*Baltimore Sun*, April 16, 1965). Guilford Association president Gerald S. Wise (see page 59) said Guilford could not possibly operate Sherwood Gardens. Mayor (and later Maryland governor) Theodore R. McKeldin promised that if the community could purchase the additional land, the city would manage the tulips. Yet by 1970, the Guilford Association found itself fully responsible for Sherwood Gardens. Today, the City of Baltimore provides no financial support for one of the most highly visited green spaces in the city. Cathy Allen, "Maryland's Green Ambassador," lends a hand at the annual tulip dig (left), and two tired but happy diggers show off their bulbs (below). (Both, Brian P. Miller Photography.)

An impromptu volunteer who charmed his way into a tulip dig promotional shoot, a Guilford dog (above) lounges in Sherwood Gardens. In 1948, Sherwood's head gardener Clarence G. Hammond sorts signage for the coming tulip display (below). The sign at the bottom reads "no dogs please." Hammond holds a card for the Darwin tulip Charming Beauty. Hammond grew up near Guilford and recalled, "There was no garden then but a pond where bullfrogs croaked and dragonflies flashed in the sun. The grownups hated this place, for we played hooky to hunt the frogs and came home covered with mud" (*National Geographic*, May 1956). He retired after 20 years of service and, like Sherwood, passed away in 1965. (Above, Balance Photography; below, photograph by A. Aubrey Bodine, courtesy of the *Baltimore Sun*.)

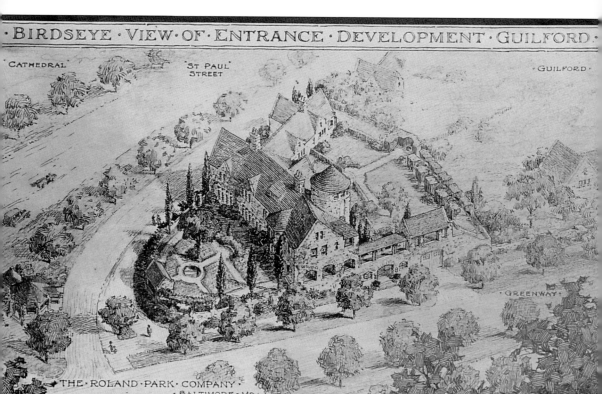

Guilford Gateways (Gateway Park) is an accidental park north of University Parkway and south of the Gateway Houses. By 1914, Grosvenor Atterbury (1869–1956) had developed plans for this site, but Bouton did not use them. In 1939, plans were unveiled for a 102-unit apartment building, sparking a near riot among Guilford residents. John W. Sherwood (pages 118–120) encouraged the community to take legal action, saying that "we owe it to our children to see that this thing does not materialize. It may mean the complete downfall of this neighborhood in a generation" (*Baltimore Sun*, March 18, 1939). In May of that year, the Guilford Association brought the Roland Park Company to court. Legal counsel planned to call as many as 100 witnesses to testify they had been told at the time of purchase that Guilford was to be restricted to single-family homes. Presiding judge Rowland K. Adams ruled in the community's favor. Residents raised $41,000 to purchase the parcel. The landscape architect H. Clay Primrose offered his design services, and John W. Sherwood managed the planting. The Roland Park Company donated a large pine tree—a peace offering of sorts. (Records of the Roland Park Company, MS 504, Box 292, Special Collections, Sheridan Libraries, Johns Hopkins University.)

In 1954, an antique Italian wellhead was installed in Gateway Park to serve as a monument to to Roland Park Company president Edward H. Bouton, who had passed away in 1941. This monument, minus its ornamental ironwork, still stands. (*Gardens, Houses and People* 1954 © Enoch Pratt Free Library, Maryland's State Resource Center. All Rights Reserved. Used with permission. Unauthorized reproduction or use prohibited.)

BIBLIOGRAPHY

Belfoure, Charles. *Edmund G. Lind: Anglo-American Architect of Baltimore and the South*. Baltimore: Baltimore Architecture Foundation, 2009.

Buckler, W.H. *Assembling the Homewood Site*. Baltimore: Johns Hopkins University, 1941.

Fisher, L. McLane, Charles M. Nes, Jr. and Carson M. Cornbrooks. *The Architectural Firm of Edward L. Palmer, Jr. and Its Successors 1907–1982*. Baltimore: 1983.

French, John C. *A History of the University Founded by Johns Hopkins*. Baltimore: The Johns Hopkins Press, 1946.

Glotzer, Paige. "How Suburban Developers Circulated Ideas about Discrimination, 1890–1950," *Journal of Urban History*. New York: SAGE Publications, 2015.

Guilford National Register Committee. National Register of Historic Places Registration Form Guilford Historic District. Baltimore: September 2000.

Hayward, Mary Ellen, and Charles Belfoure. *The Baltimore Rowhouse*. New York: Princeton Architectural Press, 2001.

Higham, Eileen. *Tuscany-Canterbury: A Baltimore Neighborhood History*. Baltimore: Maryland Historical Society, 2004.

Moudry, Roberta M. "Gardens, Houses and People: The Planning of Roland Park, Baltimore." Unpublished master's thesis, Cornell University, January 1990.

Paul, J. Gilman D'Arcy. "A Baltimore Estate: Guilford and Its Three Owners," *Maryland Historical Magazine* 51, no. 1 (March 1956).

Schalck, Harry G. "Planning Roland Park, 1891–1910," *Maryland Historical Magazine* 67, no. 4 (Winter 1972).

Stockett, Letitia. *Baltimore: A Not Too Serious History*. Baltimore: Norman Remington, 1928.

Thomas, Ebenezer Smith. *Reminiscences of the Last Sixty-Five Years, Commencing with the Battle of Lexington: Also, Sketches of His Own Life and Times*. Hartford: self-published, 1840.

Verheyen, Egon. *Laurence Hall Fowler, Architect (1876–1971): A Catalogue of Drawings from the Milton S. Eisenhower Library of The Johns Hopkins University*. Baltimore: Johns Hopkins University, 1984.

Waesche, James F. *Crowning the Gravelly Hill: A History of the Roland Park-Guilford-Homeland District*. Baltimore: Maclay and Associates, 1987.

INDEX OF ARCHITECTS

DISCOVER THOUSANDS OF LOCAL HISTORY BOOKS
FEATURING MILLIONS OF VINTAGE IMAGES

Arcadia Publishing, the leading local history publisher in the United States, is committed to making history accessible and meaningful through publishing books that celebrate and preserve the heritage of America's people and places.

Find more books like this at
www.arcadiapublishing.com

Search for your hometown history, your old stomping grounds, and even your favorite sports team.